SkyTrain Explorer

SkyTrain Explorer

Heritage Walks from Every Station

John Atkin

SkyTrain Explorer

Cover, and interior design by John Atkin
Glossary illustrations by Jo Scott B

Printed and bound in Canada

Library and Archives Canada Cataloguing in Publication

Atkin, John, 1957-
 Skytrain explorer: heritage walks from every station/John Atkin

ISBN 1-894143-08-6

1. Vancouver (B.C.)—Guidebooks. 2. Lower Mainland (B.C.)—Guidebooks. 3. Walking—British Columbia—Vancouver—Guidebooks. 4. Walking—British Columbia—Lower Mainland—Guidebooks. 5. Local transit—British Columbia—Vancouver—Guidebooks. 6. Local transit—British Columbia—Lower Mainland—Guidebooks. I. Title

FC3847.7.A84 2004 917.11'33045 C2004-904229-7

Don't take my word for it, don't bother with my list of alternative attractions, discover your own. In the finding is the experience.

Iain Sinclair
London Orbital

Everywhere is walking distance if you have the time.

Steven Wright
Comedian/Actor

SkyTrain Explorer

Contents

Acknowledgements

Thanks are due to the staffs of the City of Vancouver Archives and Special Collections, Vancouver Public Library for their usual helpfulness and assistance, to the band of hardy souls who participated in the original tours of these station areas and, as always, Robin.

My thanks too to the patience and support of my publisher.

Introduction

T he trains on the Expo line of SkyTrain zip along their route picking up and dropping off passengers at any one of the stations between downtown New Westminster and Vancouver.

The SkyTrain line follows much of the Vancouver and Westminster Railway's original 1891 Interurban line between Vancouver and New Westminster. It cut through forest, bridged rivers and swamps, while offering early residents the best in current transportation technology; it turned what was previously an overnight journey into a reasonably comfortable hour. Today, we can zip between the two cities along an elevated guide way in automated trains, controlled by computers in Burnaby, in just about thirty minutes. Since its inception in 1986 the system has been popular with riders - in 2003 the system carried almost 34 million passengers - but I wonder how many of them have ever decided to get off at a different stop one day and go exploring.

That's what I hope to encourage with this book since exploring - being curious - is the best way to experience new and familiar neighbourhoods.

As with *Vancouver Walks*, there is no index but people and places have been cross-referenced in the text. There is a small glossary of architectural terms at the back of the book, illustrated by my very good friend Jo Scott B, to assist in identifying the style of some of the buildings on the tours.

John Atkin
Spring 2005

Vancouver

What to see along the line:
Vancouver to Burnaby

The line is underground through the downtown, but just after leaving the Waterfront station you can look into the basement of the Marine Building.

At Chinatown/Stadium station, International Village Mall, historic Chinatown and the Dr Sun Yat Sen Chinese Classical Garden is to your left.

On the right before Main Street there is a great view down False Creek to Granville Island.

From Main Street, the Victorian homes of Strathcona are on the left and Mt Pleasant is to the right.

The SkyTrain passes over what was the eastern basin of False Creek.

Look for the mosaic wall at Clark Park just past Broadway. To the right is Trout Lake one of Vancouver's only remaining natural lakes.

At Nanaimo station there are excellent views of the mountains to the north.

At Joyce the view to the right is of an old lake bed which was drained in the 1880s for farm landand.

Just before the Patterson station is the 1977 Telus "boot" building on the left.

St John the Divine Church is to the left on Kingsway, look for the steeple.

1

Waterfront Station

For many years the station concourse of the Canadian Pacific Railway station was an empty space with a few hard luck men occupying the waiting room benches. The place would briefly come alive with the arrival of a train. It felt as if the building's future was bleak and that demolition couldn't be far off. Passenger rail service was reorganized under the Via Rail banner in the mid-1970s and the former Canadian National station near Terminal Avenue (see page 47) became the Vancouver terminus for trains. For the first time in ninety years there were no passenger trains calling at the CPR's downtown station.

But, in 1977, the station gained a new lease on life when the Seabus passenger ferry service began operating between downtown and the North Shore. The new SkyTrain system, unveiled in time for Expo 86, the World's Fair hosted by Vancouver, began using the station in 1986. Finally with the creation of the West Coast Express service in the mid-1990s trains once again started calling. Apart from transportation, the station also has the honour of being the location for the first Starbucks Coffee outlet outside of the United States which opened in 1987.

The red brick building with its impressive colonnade is the creation of the Toronto-based architects Barott, Blackader and Webster who chose the then popular neo-classical style for what would be the third station for the railway on or near the site. The first was not much more than a decorated shed but it did see the arrival of the first transcontinental passenger train in 1887 (Engine 374 which pulled that first train is now sitting in restored splendour in a specially built pavilion at the Round House Community Centre at the corner of Davie and Pacific). Eventually, as the city grew, new and larger premises were needed and the Railway built an imposing chateau-styled building at the foot of Granville Street as their second station. Unfortunately, that building lasted just a few years before being demolished and replaced with the current 1912 structure due to, so the rumour goes, the substandard quality of the locally made bricks.

Coming up from the SkyTrain platform into the concourse of the station

you enter one of the finest spaces in the city. From here passengers waited to board trains to the east, many fresh off the sleek trans-Pacific Empress liners tying up after a voyage from the Orient. While waiting for the call to board their trains passengers could get a head start on their journey through the Rockies by looking up. High above are a series of oil paintings, installed in 1916, done by Mrs. A. Langford, the sister of the CPR's Western superintendent F.W. Peters, depicting mountain scenes along the rail line. In the southeast corner of the room are the North Shore's Lions. Before a restoration and cleaning in the 1980s removed seventy years of grime and smoke, the paintings were little more than black rectangles on the wall.

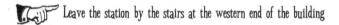 Leave the station by the stairs at the western end of the building

At the top of the stairs stop and take a look back out over the concourse. In the 1960s an ambitious plan for Vancouver's waterfront, launched under the name Project 200, - the 200 representing the initial investment of two hundred million bucks in the development scheme - called for the redevelopment of much of the city's historic core with a series of high-rise towers on a podium astride the rail tracks and a new waterfront freeway. Luckily for Vancouver the project did not get off the ground except for the building immediately to the west of the station. When 200 Granville was built no one was anticipating that the CPR station would remain and so they slammed the tower's plaza podium right up against the building; when the station was extensively renovated in the 1970s the staircase was added turning what was a mistake into an interesting vista and valuable pedestrian link.

The plaza terminates Granville Street and is a popular view point to watch helicopters, seaplanes, harbour traffic and the cruise ships. And at the top of the office tower's thirty-two storeys all of this activity is watched from the harbour traffic control tower because, along with all of the ships, Vancouver's harbour is the fifth busiest airport in the province with 60,000 landings and takeoffs each year.

The completion of the Price Waterhouse Coopers building in 2003 has helped the plaza immeasurably and now provides some useful links to Howe Street and the Convention Centre.

 Cross Cordova Street by the pedestrian bridge

The pedestrian bridge over Cordova Street is an excellent place to stop and look at the contrast between east and west. To the east is the CPR Station, the warehouses and hotels of Gastown and above it all the Woodwards's "W", relit, though not yet revolving, after being dark for so many years. Woodwards was a regional department store that had its roots in Vancouver but faced bankruptcy in the early 1990s soon after its one hundredth anniversary. To the west is the booming Coal Harbour area once home to the CPR's freight yards, numerous shipyards, a sawmill and other industrial uses. Once promoted in the 1870s as New Liverpool the area is now a boomtown of a different sort as the condominiums and office buildings rise from the former beach.

Sinclair Centre, a four building complex of offices and shopping, is on the south side of Cordova and is the result of an innovative rehabilitation in the 1980s by Public Works Canada and the architectural firm of Henriquez and Partners. The exteriors of all four buildings were carefully restored and a covered courtyard was created in the middle of the group. The youngest of the four is the 1935 Federal Building designed by McCarter and Nairne, probably best known for their work on the Marine Building (see page 28), in a restrained Art Deco style. The pedestrian bridge gets you up close to some of the decoration, including the delightful carved fish, along the Granville Street facade. The fish which are commonly thought of as dolphins are actually sturgeon. The sturgeon has been considered a royal fish from the time of Edward the Second and the Lord Mayor of London can, if he wishes, claim any and all sturgeon caught in the Thames above London Bridge.

The 1905 Post Office, designed by the Public Works Department architect David Ewart, is the oldest building in the complex and occupies the promi-

nent corner of Granville and Hastings at the centre of what was the city's financial district. The building's imposing granite facade features the crests of British Columbia and Canada on two faces of the clock tower. This was a standard design for the department, an excellent example of the design can be seen in Moose Jaw Saskatchewan rendered in Tyndal limestone. In the same year Ewart designed the Royal Canadian Mint on Sussex Drive in Ottawa.

Before ducking into the Sinclair Centre, take a moment to cross the street and look at the 1908 Canadian Bank of Commerce on the southeast corner of Hastings and Granville, designed by the Toronto-based firm of Darling and Pearson, Canada's preeminent architects of the day - best known for their work on the Centre Block of the Houses of Parliament in Ottawa. Their design for the bank is an imposing granite temple meant to express the permanence of the institution. It was the bank's headquarters until its 1995 conversion into the new flagship store for Birks Jewellers. During the renovation the ornate bronze doors of the Hastings Street entrance were pulled from their pockets in the wall where they had languished for years, polished, and are now used each night when the store closes. When the store moved from its long time Georgia and Granville location - the store opened there in 1912 in the ornate Somervell and Putnam designed building; the demolition of the original building in 1974 was widely decried by the public, as was the nasty replacement office tower - they brought their famous clock with them. It's really a homecoming of sorts since the clock originally sat across the street in front of Trorey's Jewellers before being purchased by the Birks operation.

Trorey's building was knocked down for the construction, in 1929, of the Art Deco Royal Bank of Canada building. Designed by S.G. Davenport of Montreal the bank's skyscraper is only half of the proposed design since its construction coincided with the onset of the Great Depression. The exterior is an interesting combination of Art Deco and Romanesque motifs - take a look at the entrance arch with its mythological beasts and plant forms - while the interior takes on a odd mixture of the classical and Moorish styles. Of particular note are the painted ceilings inside; look for the medallions with mottos such as "No Labour, No Bread", "Colonies and Commerce" and "Speed the Plough".

☞ Cross Granville and return to Sinclair Centre. Walk west on Hastings to the shopping mall entrance and go inside.

The Hastings Street entrance and elevator lobby of the Sinclair Centre present a striking contrast to the building's facade because inside it's all out Art Deco, a redecoration prompted by the completion of the Federal Building in 1935. Of note, and hard to miss, are the extraordinary bronze elevator doors flanked by the "frozen flower" column capitals. Once out in the covered courtyard you can see the mix of original and new architecture. Walking to the Howe Street exit takes you along what were the outside walls of the Winch Building and Customs Examining Warehouse.

Outside take a look at the Winch Building to the south, it was the first commercial building west of Granville Street and as such signalled an end to the residential nature of this part of town. It was built by R.V. Winch of the Canadian Pacific Canning Company, the company responsible for the first trainload of tinned salmon to be shipped from Vancouver in 1895. While the building looks solid with its granite walls it's also very modern since the architect, Thomas Hooper, designed it with a steel frame. The solid looking Customs Examining Warehouse to the north was constructed in 1912.

At the intersection of Cordova and Howe it's possible to look over the railings and see the depth of the building where it had been built to take goods directly from the trains and wharves. On the opposite corner a glimpse is just possible of the original escarpment face. Downtown Vancouver stopped here. It's just possible to imagine the hustle and bustle of the early port; with the CPR's Empress steamers arriving from Asia, the Princess boats arriving from Vancouver Island and coastal destinations, and the racket of shunting freight cars along the tracks below.

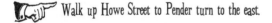 Walk up Howe Street to Pender turn to the east.

Opposite the Sinclair Centre, at the southeast corner of Howe and Hastings, is the Bauer building named after its builder William Alfred Bauer (see pg 59) a typical Edwardian office building. Look up to see the terra cotta decoration including the lion heads on the Howe Street side of the building.

At the northeast corner of Pender and Howe is the restrained Art Deco/ Gothic of the Hall Building designed by Winnipeg-based Chivers and Northwood in 1929. The building's exterior uses Manitoba Tyndall limestone which is noted for both its colour and the fossils which can be seen in the stone face. The Hall Building reflects the Gothic Skyscraper style of the Stock Exchange Building across Howe Street. Designed by Townley and

Matheson (architects of Vancouver's Moderne city hall at 12th and Cambie) their building uses the popular gothic motif for both the exterior - note the blue, green and cream terra cotta - and the wonderful chapel-like elevator lobby where the ceiling features fresco paintings of the provincial crests.

East on Pender Street, the 1970s addition to the Hall Building for the Montreal Trust is a handsome piece of respectful architecture.

The impressive Rogers Building of 1912 takes up most of the view from the northwest corner of Granville and Pender. Built to the designs of Seattle-based architects Gould and Champney, it's faced in white terra cotta. The building has been well cared for by its owners who have restored a number of features in an ongoing program of work. Look way up at the cornice to see a number of lion heads staring down at you. The building is named for Jonathan Rogers, a builder, developer, Park Board chair and philanthropist, who liked to claim he was the first off the first transcontinental passenger train that rolled into the city in 1887. On the opposite corner the former Bank of Montreal, part of Simon Fraser University and home to their business school, is another Vancouver project by Seattle-based architects. This time the prolific partnership of Somervell and Putnam produced a modest banking hall for the Merchants Bank in 1916. Taken over by the Bank of Montreal shortly thereafter, the building was doubled in size using the designs of Montreal-based Kenneth Guscott Rea in 1924.

> **SkyTrain Notes**
> The first part of the SkyTrain route to New Westminster utilizes the former CPR freight tunnel under downtown Vancouver completed in 1932. The tunnel was designed to shift box cars and freight from the CPR False Creek yard near Chinatown to Burrard Inlet. Previously trains would cross near Hastings and Carrall and tie up traffic at all times of the day, it finally got to be too much for the city - the trains crossed four major streets - and the tunnel was constructed to the relief of everyone. In 1985 it was altered to accommodate two levels of track for SkyTrain operation.

Next door at 626 Pender is another Somervell and Putnam creation, the London Building, designed in 1912 during a boom in office construction along the eastern edge of the business district. Upon completion the firm moved their business into a top floor office in the building. With the building boom the partners were kept busy with a number of commissions including the Skyscraper Gothic Yorkshire Trust Building around the corner at 525 Seymour.

The rest of the block next to the London building is made up of an inter-

esting collection of early buildings. There has been a hotel on the site of the Picadilly Hotel since the late 1880s; the current hotel dates from the early twentieth-century. The building is distinguished by the sheet metal bay windows out over the street, they repeat in the back lane which is somewhat unusual. And the little modern building next door is actually rather ancient having been built in 1910 for the Vancouver Trust Company. In 1942 Semmens and Simpson modernized the building and had their offices there for a number of years. The firm designed the award-winning main branch of the Vancouver Public Library on Burrard Street in 1957, today the home of Virgin Records. At the end of the block on the southwest corner is a survivor of another age. The Clarence Hotel has been sitting here serving beer since 1896 (give or take a few years for prohibition) and has the distinction of having one of the oldest liquor licenses for an original location in the city. The hotel has suffered over the years from many renovations, but if you cross the street and look carefully the faded hotel sign painted on the Pender facade is trying to peek through the peeling paint. At one time the entrance on Pender was an elegant arch which spanned the width of the building.

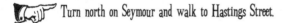 Turn north on Seymour and walk to Hastings Street.

Conference Plaza takes up the north side of Pender between Seymour and Richards and almost all of the block to Hastings. This large development is a combination of condominiums, hotel, retail space and a conference centre. Of interest on Pender Street is that the developer has insisted that neon is used for the retail signage bringing a little bit of colour in the evening to a drab stretch of road. On the Hastings Street side of the development the most notable structure is the former Union Bank Building, another Somervell and Putnam creation done in the 1920s, which is now part of the growing downtown campus of Simon Fraser University. The bank was based on the idea of an Italian palazzo and is one of the most elegant of the city's temple banks. The bronze doors which grace the Hastings Street entrance are the originals but had been missing for years. A good deal of detective work by Cathy Barford of the Community Arts Council located them in a local restaurant enabling the University to purchase them and reinstall them. During the conversion of the banking hall to the Wosk Centre for Dialogue great care was taken to ensure the survival of the ornate plaster ceiling and other notable features. Unfortunately the historic Innes-Thompson Building of 1889 - one of the early brick commercial buildings in this part of downtown - was sacrificed for the fairly bland Delta Hotel next door.

Directly across the street is the former Spencer's Department Store, designed by McCarter and Nairne in 1928. David Spencer started out in Victoria before moving to Vancouver. In the 1940s the store was purchased by the T.Eaton Company and after they moved to Pacific Centre, Sears tried to make a go of the location but gave up on a downtown store for almost twenty years until moving into the old Eaton's at Georgia and Granville when Eaton's went bankrupt. In the 1970s the old store received an addition in the form of an office tower and a Seattle Space Needle inspired lookout which is a popular tourist attraction. Since the 1990s Simon Fraser University has been occupying a good portion of the former department store as their downtown campus, bringing new life to the area.

Look to the northwest corner of Hastings and Seymour, the building that looks like it's waiting to take flight in a cheap 1950s sci-fi flick is the former Price Waterhouse Building. This 1980s "thing" replaced the rather lovely 1888 Richardsonian-Romanesque Empire Building. The strange dome on the corner is actually a public park given to the city by the developer.

 Walk east to the corner of Hastings and Richards, turn north and walk to Cordova.

At the end of the block next to the Delta Hotel is the 1914 Standard Building, originally known as the Weart Building. John Weart, who the building was named after, came from Ontario and was responsible for raising the money to complete Christ Church Cathedral (see page 22), he was also the Reeve of Burnaby in 1912 and was elected to the provincial legislature in 1916 for the municipality of South Vancouver. This huge building is decorated with terra cotta in a variety of motifs including the Gothic inspired upper stories.

Across Richards is the rather neglected looking Bank of British Columbia. This once impressive building was designed in 1889 by T.C. Sorby using the Italian Renaissance Revival style. Despite the neglect there are hints of its former grandeur, look for the pediments over the windows and the arch and columns on the Richards Street side. As well look down at the sidewalk on Richards for the earliest glass prisms set into the sidewalk. Prisms like these magnified the light to illuminate basements which were built out underneath the sidewalks. The most common glass prism is either square or rectangular in shape; the purple colour most often associated with them comes from years of exposure to sunlight, originally they

were clear glass. Step across the lane to look at Century House with its "winged" beavers flanking the lighthouse at the top. The granite-faced building dates from 1912 and was the head office for the Canada Permanent Mortgage Corporation.

Back at the corner, look east for a glimpse into early Vancouver. Almost all of the buildings in the blocks stretching towards Cambie are from the early part of the twentieth-century and form one of the most complete Edwardian commercial streetscapes in the city. The view terminates with the magnificent Dominion Building and its orange mansard roof.

Heading down the hill towards Cordova Street brings us to the edge of Gastown. Directly ahead is the massive bulk of the Kelly Building designed by W.T. Whiteway. Begun in 1905, the structure has had a number of additions over the years making it the largest warehouse in Gastown and while the exterior is brick, the structure is all timber post and beam inside. It was renovated in the 1980s for offices and retail and renamed the Landing. Across the parking lot to the west is the CPR Railway Station, the starting point for this tour. From here the Railway's memorial to men lost in the First and Second World Wars can be seen. The bronze "Angel of Victory" was cast in 1922 and besides Vancouver, copies were placed in Winnipeg and Montreal. The design was by the Ottawa sculptor Coeur de Lion MacCarthy.

Weary walkers can rest and grab a pint in the brew pub in the Landing or take advantage of the restaurants and coffee places in Gastown.

2

Burrard Station

Burrard Station is a surprise. Coming out onto the station concourse you are greeted not by the sounds and sights of the city but by a lush landscape of flowering trees and the sound of water. The station feels more like a park than a transit stop and in mid-March when the double row of flowering cherries on the upper level are in bloom the place is magical.

 Walk up the stairs to the west of the station by the fountain and walk to Burrard by way of the Melville Street garden path. Walk south to Georgia Street.

Before the office towers, Burrard Street and the surrounding area was a residential neighbourhood. The Canadian Pacific Railway built their first hotel at Georgia and Granville and as businesses began to line Granville Street between the railway station and the hotel, residential development followed on the side streets such as Seymour, Richards, Howe, Hornby and Burrard.

In 1888 it was decided to build a church to attend to the needs of the neighbourhood. The foundation was laid in 1889 but the funds were not available for completion until 1895. There was much concern regarding the unfinished church because the CPR, ever mindful of appearances, objected to the unfinished bunker-like building sitting on a prime corner and parishioners feared they might lose their site. But all was well when a complicated scheme was worked out by J.W. Weart to raise the necessary money. C.O. Wickenden's original design has had three major additions to it over the years. In 1929 the church became the cathedral for the diocese replacing New Westminster's Holy Trinity Cathedral.

The area around the church began to change soon after its completion and in a few years found itself surrounded by offices, hotels and, of all things, automobile dealer's showrooms. Until the mid-1960s Burrard Street was the place to shop for a new car. Dealerships and car lots lined the street from False Creek to the Inlet selling Chryslers, Kaisers, Humbers,

and Hillmans. Cadillacs were sold at the Bowell Maclean Motor Company show-room which is now the site the Burrard SkyTrain station.

The pressure from development has threatened the church only once in its long life and that was in the 1970s when an Arthur Erickson designed office tower was proposed for the cathedral's site. The parishioners voted for their own ca-thedrals' destruction but a hew and cry from a concerned public prevented the demolition and prompted the City to des-ignate the church. A new scheme emerged whereby the church remained and a park was created behind it. The unused density from the church and park was piled onto a new office tower at the Dunsmuir Street end of the site. In 2003/04 the cathedral interior went through an extensive restoration and renovation. The church is open to the public, check the times and do take a look.

Across the street from the cathedral is the Fairmont Hotel Vancouver originally built by the Canadian National Railway. Once one of the most prominent build-ings on the city's skyline; today it's hid-den by the forest of office and condominium towers.

Author Neale Adams relates in *Living Stones*, his 1989 history of Christ Church, how the building was finished:

Christ Church was completed due to the smart thinking of a 32-year-old law student, J.W. Weart. He incorporated The Christ Church Building Company Ltd which was authorized to issue up to 600 shares of stock. The value of each share was set at $100. One hundred shares went to the church in exchange for title to its assets and 400 shares were sold to subscribers, most of them men in the congregation.

Each purchaser undertook to pay up to $100 per share if called upon, but initially only $10 was collected -- at the rate of a dollar per month for ten months. This gave the building company $4,000 cash and an uncalled asset of $36,000. Weart then went to the Sun Life Insurance Company and, putting up the building company's assets as security, obtained a mortgage loan of $18,000. The church now had $22,000 in cash -- $4,000 from the sale of shares, and $18,000 from the insurance company. Sun Life, however, as added security, insisted on writing three 20-year life insurance policies on certain church members. The building company agreed to pay a single, $10,000 premium for this insurance. Now they had $12,000 cash and a big mortgage at six per cent interest -- high for the time. With city taxes, the congregation was obligated to pay $2,000 annually. To some it might have seemed a bit of a shell game, but Weart's scheme worked: the recession might continue, but with the $12,000 the church was completed.

Before the First World War the Great Northern and Canadian National railways sought permission from the City of Vancouver to fill the eastern end of False Creek from Main Street to Clark Drive and use the new "flats" as freight yards. In return the City demanded that the Canadian National Railway build a grand hotel in the downtown. The Railway turned to their own Montreal-based architect John Archibald, who was assisted by John Schofield, to design the new hotel. Construction began in 1929 but it was not a good year to begin a project such as this, and the hotel was left as a steel skeleton on the skyline until it was rushed to completion in time

for the Royal visit of 1939. The hotel's designers kept with the Canadian railway tradition of looking to the Scottish Highlands and France for design inspiration.

A closer look at the hotel reveals a menagerie of beasts, both real and imagined, crawling over the building: they include some rather large lizards curled up under the balconies; gargoyles and griffins near the roof; lions in various guises; deer, pheasants, and foxes around the entrances. I'm sure the architects understood the symbolism they were playing with because a dragon/serpent can represent relaxation, wisdom and silence and because it was associated with clouds it was believed to be a rainmaker (suitable symbol for this city); griffins are symbols of the sun, wisdom, vengeance, strength, and salvation; the lion is the emblem of earthly power, strength, dignity, courage, and, of course royalty. Over the entrances to the hotel the Greek god Hermes watches over guests since he is the god of commerce and the market, hence the patron of traders: but also the patron of thieves.

 Walk west on Georgia, cross Burrard Street and walk to Bute

It is hard to imagine now but until World War Two Georgia Street, west of Burrard, was almost entirely residential. Many of the homes were modest affairs but there were many fine homes scattered along the street including, the Rogers, Abbott, and Keith residences. With an expanding downtown, business slowly crossed Burrard: some of the first to establish themselves on the street were the automobile dealers such as the Consolidated Motor Company, agents for the Hupmobile. Gradually the showrooms were joined by apartment buildings, hotels and other businesses and the homes on the street were turned into rooming and boarding houses before suc-

cumbing to demolition in the 1950s and 60s. One example was the impressive home of CPR Land Commissioner J.M. Browning at the corner of Burrard and Georgia, on the site of todays Royal Centre. Browning's home was greatly expanded and was raised up over two storeys to become the upper part of one of the wings of the Hotel Belfred, later the Glencoe Lodge.

One of the first 'modern' buildings to appear on Vancouver's skyline was the 1956 C.B.K. van Norman designed Burrard Building on the southwest corner of Georgia and Burrard. (that same year both the B.C. Electric Building at Nelson and Burrard, and the Vancouver Public Library at Burrard and Robson were already underway.) Built on the site of the Wesley Methodist Church and an early White Spot restaurant, the striking building took its cues from International-style buildings such as the influential Lever Building in New York. For much of its life the the major airline companies occupied the ground and mezzanine floors with their ticket counters (across the street on what is now part of the Royal Centre was the Airline Limousine Service waiting room) In the 1990s the building was modernized with black reflective glass and stainless steel highlights which robbed the building of any character it once had.

Next door to the Burrard Building was the Ritz Hotel, and its popular basement beer parlour a hang out for art students for many years. The Ritz belonged to an era where only hotels were able to hold a liquor license and beer parlours had no windows just in case an innocent passerby might look in. The Ritz was demolished in the 1980s. On the north side of Georgia, the bold architecture of Arthur Erickson's MacMillan Bloedel Building, designed in 1968, is still eye catching. Take a look at the end of the building on Thurlow Street and you'll see the building's profile is that of a tree trunk; MacMillan Bloedel was British Columbia's preeminent lumber firm.

The Terasen Gas Building at the northwest corner of Thurlow and Georgia occupies the original site of the Vancouver Art Gallery. During the Great Depression it was occupied, along with the Post Office, by unemployed men unhappy at the government relief efforts and conditions in the work camps. The curator said the men took care during their stay not to damage any of the paintings. Later, the men would rally at Victory Square where the mayor of the day, Gerry McGeer, stood on the steps of the *Province* newspaper building and read the Riot Act.

The ragged looking skeleton sitting to the west of the Terasen Building is what's left of the 1957 Shell Oil Building, one of a number of handsome modern office buildings built along this stretch of the street. The Shell

building was stripped to be rebuilt as an upscale private club, but got hit in the economic downturn in the early 1990s.

The south side of the block was home to Begg Motors and the J.M. Brown Motor Company. In between these showrooms was the First Church of Christ Scientists designed in 1918 by Matheson and De Guerre. This modest building, designated as a heritage building by the City, will be incorporated into the Shangri La development, one of the tallest buildings in the city.

The northwest corner of Bute and Georgia is graced with the 1909 Banff Apartments (Florence Court). H.B. Watson, the architect, originally envisioned two, rather fanciful, large domes topped with flag poles at the corners of the building. Across the lane behind the Banff is a home which has hung on long after its neighbours have disappeared. It shares the block with the Stadacona Apartments of 1909 which is interesting for its use of sheet metal for the architectural details such as the cornices and bay windows. The apartment building was built by John Banfield a real estate promoter who was busy in both Vancouver and Grand Forks. The prolific firm of Parr and Fee provided the design.

SkyTrain Notes: Construction of the first phase of SkyTrain took four years and cost almost $900 million. It opened for passenger service January 3, 1986

While not on the route, it is worth detouring down Melville Street to Jervis to look at the Jacobean-inspired Banffshire Apartments with its deep light wells (though one has been marred by the insertion of an elevator shaft) and decorative sheet metal work. Originally called the Felix, Latin for happy and fortunate, the building was completed in 1911 to the designs of local architects Thorton and Jones.

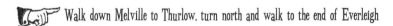 Walk down Melville to Thurlow, turn north and walk to the end of Everleigh

Just behind the Banffshire Apartments, John Nickson built a large house in the 1880s for his five daughters, three sons, two lodgers, a cook and his wife. Along Melville, between Bute and Thurlow, a number of fine homes like Nickson's were built, including one for Dr Schofield which cost three thousand dollars and was designed by W.T. Dalton who lived around the corner on Everleigh Street.

Everleigh Street is an odd little survivor; cut off from Burrard Street by the bulk of the Bentall development it looks more like a back lane than a

street. Even though it is now lined with service and parking garage entrances it was once a street of modest homes where, in the 1900s, the likes of Palace Livery Stables manager Mr. O'Conner and Giles Shelton, a car inspector for the CPR, lived. By the 1940s most of the homes had been replaced with a variety of businesses.

Turn north through the passage way to Pender Street, turn west and walk to Thurlow Street. Cross Pender and walk north to Hastings on Thurlow.

The remains of Portal Park are at the northeast corner of Thurlow and Hastings. Built over the entrance to the CPR's downtown freight tunnel the park once offered views out over the water from a viewpoint perched on the edge of an escarpment. Unfortunately the extension of Cordova and Thurlow Streets in 2004 turned this once interesting space into something rather ordinary. Also lost is the opportunity to sit, reflect and view the water where, from May until mid-July 1914, the *Komakata Maru* sat at anchor with 376 Sikh passengers on board. The ship was detained in the harbour and her passengers, all British subjects, denied entry to the country - Canada had a policy of allowing only those immigrants who managed a nonstop passage from India entry; something not possible at the time. The *Komakata Maru* was chartered for the voyage and made stops in Hong Kong before arriving in Vancouver. A standoff of sorts developed because the ship refused to leave without provisions yet the government initially wouldn't allow provisions to be brought on board. Everyone was stuck on board at the height of summer in rotten conditions. There is a small plaque in the park at the far north end on a planter to commemorate the shameful incident and the ship is part of a sculpture on the roof of the Vancouver Art Gallery. (see pg36)

The park connects to the office plazas next door. The Shaw Tower directly in front of the park was briefly the tallest building in Vancouver but has been surpassed by new construction. The tower is interesting since it combines residential and business uses, including the broadcast studios of Shaw television, in one complex. To the east on Hastings are some of the older, but still striking, office towers. The Guinness Tower at 1055 West Hastings dates from 1967 and is the work of Charles Paine. Look up to see the family heraldry in bronze displayed against the marble panels surrounding the outside of the lobby. Inside the lobby is "The Fathomless Richness of the Seabed" a large ceramic abstract depiction of the sea bottom by artist Jodi Bonet. Across the street, separated by ten years

but linked with a pedestrian bridge, is Oceanic Plaza at 1066 West Hastings also by Charles Paine and the Guinness family, an updated version of the earlier tower.

Next door to the Guinness Tower is the modest Mission Revival Quadra Club designed by Sharp and Thompson in 1929. The bulldozers must be lurking somewhere. The club butts up against the Marine Building one of Vancouver's best buildings of any period.

The Marine Building was started on the eve of the Great Depression and the original developer, the Stimson Company, lost their shirt on the whole enterprise. But despite the hardship the building is a treat for the eyes. The exterior is festooned with a variety of marine themed decoration from battleships to King Neptune, sea horses to sea weed. The entrance arch displays the history of Pacific Coast exploration with the ships of Drake, Cook, Quadra and Vancouver while the history of commercial shipping is illustrated by the Hudson's Bay Company's *Beaver* and the CPR Empresses.

Inside the architects, McCarter and Nairne, were influenced by seaside grottos and Mayan temples to arrive at the spectacular lobby space. Tiles by the noted maker Batchhelder decorate the walls, the elevator cabs are inlaid with exotic woods, but the floor is new - the original was a crazy quilt pattern of linoleum made in Scotland especially for use on ocean liners.

Across the street the Daon Building is a thoughtful composition which captures the reflection of the Marine Building in its bronze glass facade. Next to the Daon Building is the home of the Vancouver Club with its imposing Georgian facade which would look right at home in either London or New York. Looking a little lonely and out of place is the facade of the Hudson's Bay Insurance Company on the south side of Hastings. It was stuck up against the Bank of Canada building when the CIBC project was built in the 1980s. Its worth looking at both the facade and the Bank of Canada building since all of the bank's proportions are based on the insurance company, a relationship lost with the relocation.

 Walk south on Burrard Street to Burrard Station.

In between Pender and Hastings on the west side of Burrard is the new federal government office building which sits on the site of C.B.K. van

Norman's 1954 Custom House, destroyed despite repeated calls for its retention. After many years the vacant site was finally built upon. And the brief to the architects of the new structure? Try to reflect the previous building. The best part of the project is the Alan Storey sculpture which captures the movement of the internal elevator system.

Across Pender is the massive Bentall Centre complex begun in 1965 and comprising four towers of the same design. The construction of these towers heralded a new direction for the business district and Burrard Street. In 2003 Bentall Five was completed across the street from the original four; it is unique for being designed to be erected in two stages, the second phase will be constructed while the first phase is fully occupied, a first for North America.

3

Granville Station

G ranville Station is the deepest station in the downtown (the escalator ride to the surface gives you a good idea of just how deep it is) and comes out under the Hudson's Bay Department store and exits on Granville Street. Before stepping out onto Granville Street stop and take a look at the entrance. The stairs to the side lead up to the store through a lovely arcade of polished wood and Tyndall Stone, limestone from Manitoba which contains fossils and is valued for its mottled appearance. This small space hints at the former elegance of the company's flagship store.

The Hudson's Bay Company moved from Cordova Street to the corner of Granville and Georgia in 1893, inpart because of the efforts of the CPR at promoting its section of the peninsula as the new business district. They built their new hotel at the top of the street, the highest point in the downtown, in view of the railway station at the bottom of the street. Later the company had American architect Bruce Price, the designer of the iconic Chateau Frontenac in Quebec City, provide designs for speculative buildings along Granville to showcase the potential of the street (four of his designs were actually built on the street but sadly all have met the wrecker's ball). The enticements continued with an opera house behind their hotel and a park fronting Georgia Street. It worked.

By the late 1890s Gastown, Vancouver's original business district had evolved into a warehouse district and the centre of town had shifted to Granville and Georgia. The shift was essentially completed in 1906 when the new courthouse was built on Georgia Street next to the hotel.

The Hudson's Bay's original building was a fairly ordinary brick and stone affair, but by 1913 a new addition was taking shape. The company turned to Burke, Horwood and White, a Toronto based firm, to provide designs for a new store and they in turn looked to London and the recently completed Selfridges Store for inspiration.

Selfridges was something new in retailing; the store was one of the first to take the goods out from behind the counter and organize displays for

the customer, among other services there was an excellent restaurant with reasonable prices and an innovation which continues today, the perfume counters at the front of the store close to the entrances to draw the customer into the store.

Burke, Horwood and White borrowed heavily from the London store's design, to the point of copying it. They also borrowed the idea of staged construction since Selfridges, while it appears as one building along Oxford Street, was built in two phases with one part already open for business while the extension was under construction. The current Hudson's Bay store was started in 1912 at the corner of Seymour and Georgia and first extended along Georgia to Granville, then north along Granville in the 1920s and on Seymour in the 1940s. If you look closely at the building there are subtle changes in the terra cotta's colour indicating where the different stages of construction begin.

Across Georgia Birks and Sons, the Montreal based jewellers, hired Somervell and Putnam to design a new store and office building for them in 1912. The resulting design, with hints of the Italian Renaissance, was faced in a cream coloured terra cotta. Generations of Vancouverites knew "meet me at the clock" meant the corner of Georgia and Granville by the Birks Clock. The building, along with the Strand Theatre, was demolished in 1974 despite widespread protest and condemnation by the public. The replacement building, the Scotia Tower, is one of the least inspired buildings on the Vancouver skyline and the decision to demolish was not a good one for the jewellers, they eventually gave up the new store to return to the more elegant surroundings of a restored bank at Granville and Hastings (see page 16). Many of the original store's fittings are scattered around the city and used by other

retailers, casts of the ornate ceiling were made by the Provincial Archives and the Vancouver Museum has the office building entrance arch reinstalled in one of their galleries.

A good view of the 1912 Vancouver Block, which sits next to the Scotia Tower, can be had from any of the corners of the intersection of Georgia and Granville. The building, designed by Parr and Fee for Dominic Burns a wealthy land owner, was topped with a penthouse for Burns and a prominent clock tower. Its sixteen storey facade is clad in white terra cotta and, if you crane your neck you can see the line of six caryatids hold the cornice up. The clock, one of Vancouver's most popular landmarks, has a face over twenty-two feet in diameter which has been lit with blue and red neon since the late 1920s. In 1946 an earthquake shook Vancouver Island with enough force that it managed to stop the clock. At the time of writing major renovations are planned for a full ground floor restoration of the lobby and storefronts.

Granville Street was once known as the city's Great White Way because of the nightlife; the clubs, dance halls and movie theaters all lit with one of the largest displays of neon in North America. Sometime in the 1960s it was thought to be a good idea to turn Vancouver's main street into a pedestrian and transit mall. At the same time new bylaws limiting the size and scale of signs throughout the city were passed. The affect of all of this was to leave Granville Street in limbo - neither successful retail street nor entertainment street - until quite recently. Having the underground behemoth of Pacific Centre on the street didn't help either.

In recent years in an effort to revive the area the street has been designated an entertainment zone where night clubs are encouraged: more importantly the sign bylaw for the street has been rewritten to allow a greater array of signs and the changes are having the desired affect. New signs have been erected and old ones revived and the street is beginning to feel alive again.

The rest of the block is taken up with a new retail development finally filling the hole left by the demolition of the Castle Hotel. Also in this block was the rather nifty Sky Diner whose neon sign represented the tail of an aircraft and once inside, seated at a booth, you could watch the scenery - painted on canvas and moved on rollers - 'fly' by your window.

For many years the street photographer Foncie Pulice made the northeast corner of Robson and Granville his spot. With his homemade "Electric Photos" camera he caught people out shopping, going to the movies or on that first date, and captured a time when downtown was exciting and the place to be. Your photographs would cost three prints for fifty cents, six for seventy-five cents or eight for a dollar.

The west side of the street is taken up by the austere design of Sears, the former Eaton's department store, which is part of the three block long Pacific Centre development; its construction in the 1970s - facilitated by the City who did the land assembly - destroyed much of the early CPR initiated development along Granville Street, including, in this block, the Opera House which ended its days as the Lyric Theatre. The original Hotel Vancouver at the southwest corner of Georgia and Granville met the wrecker's ball as far back as 1939, the site then remained a parking lot for the next thirty years. The Toronto Dominion and IBM towers, quickly dubbed the "Black Towers" after their construction, and the Sears store are from the pen of Cesar Pelli. The Pacific Centre Mall was designed by Victor Gruen and Associates of Los Angeles. Gruen is considered the father of the shopping mall developing his first, the Northlands Mall, in Detroit in 1955, Pacific Centre was one of the last projects for his firm before Gruen returned to his native Austria. (see pg 89)

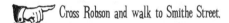 Cross Robson and walk to Smithe Street.

The canopy over the sidewalk at 807 Granville may seem excessive but it is fairly typical of Edwardian buildings downtown. The ground floor stucco and window shapes are from a former incarnation as a Sweet Sixteen clothing outlet. Next door is the wonderful 1929 polychrome Art Deco facade designed by Townley and Matheson which replaced N.S. Hoffar's 1888 efforts. The colourful building designed for the Bank of Commerce has a vaguely Egyptian feel to the architecture but displays many of the typical Deco motifs. The Medical Arts Building farther south was completed in 1923. Poke your head in through the doors to look at the richly detailed marble lobby. The elevator in this building was one of the last to have an operator.

Across the street, the Commodore Ballroom has been a fixture on the entertainment scene since its construction in 1930. A noted music venue, it also known for its sprung dance floor. The Mission Revival design has been carefully restored by the building's owner with tile work surrounding the shop fronts specially commissioned to compliment the damaged originals. And if you feel like a quick game of five pin head downstairs to the wonderfully evocative Commodore Lanes which opened in 1930 and is still going strong. Five pin bowling is a uniquely Canadian sport originating in Toronto in 1909. The pins are smaller and the lanes narrower than the ten pin game and Canada is about the only place in the world where it is played.

Next door to the Commodore was the home of Notte's Bon Ton, a Vancouver institution, which sold some of the best pastries in the city. Unfortunately when the building they had ocupied since 1936 was up for renovation their lease was terminated. The good news for Vancouverites is that they relocated to West Broadway and have managed to replicate the shop with its tea room. They still have the tarot card and tea leaf readers every day.

Outside of the Orpheum theatre and up and down the length of Granville Street over two hundred black granite disks are set into the pavement to acknowledge members of the BC Entertainment Hall of Fame. The Hall of Fame also has a display in the Orpheum Theatre. Appropriately Ivan Ackery the legendary showman and long time manager of the Orpheum has his plaque set right in front of the theatre.

The theatre, the third to carry the name, was saved from demolition by a concerted public campaign to raise the funds to allow the City to purchase and restore the theatre as the new home of the Vancouver Symphony. Designed by the noted theatre architect B. Marcus Pritica and built in 1927 the theatre was part of the North American wide chain of vaudeville theaters owned by the Keith-Albee-Orpheum Circuit which in 1928 merged with RCA to create RKO Studios.

The Granville facade gives little indication of what's inside and is really no more than a front for an elaborate bridge to get patrons over the lane and into the theatre proper. There are tours of the amazing interior - look for times at the ticket office. Also watch for one of the rare organ concerts featuring the theatre's own Wurlitzer.

Glance across at the Granville Seven Cinema on the west side of the street. The theatre complex has managed to successfully incorporate the facades of the old Paradise (later the Coronet) Theatre with its bas-relief of a dancing woman and the late nineteenth century Palm Rooms.

 Turn west on Smithe and walk to Howe Street.

From the northwest corner of Smithe the impressive Vogue Theatre is hard to miss. Built in 1941 as a live theatre it was quickly converted to a movie house. Over the years it has avoided demolition and a plan to

covert it to retail space. The interior is in the Ocean Liner streamline style. And with luck, one day, the Vogue's neon sign will be fully restored and Diana, arms outstretched at the top, will glow in gold neon once again.

The Movieland Arcade, also visible from the corner, has been a fixture on the street for decades but before it became a house of amusement it was home to the Esquire Cafe, a lovely Deco inspired restaurant.

Before heading west along Smithe look to the east; Parr and Fee's 1910 Dufferin Hotel is on the southeast corner of Seymour, across the street is Townley and Matheson's Vancouver Motors building of 1925. Soon after completion the owners decided to capitalize on the new thing in town called neon, instead of being content with just a sign they outlined the entire building in the stuff and then invited the public to watch it being turned on for the first time.

At Smithe and Howe the Arthur Erickson-designed Robson Square complex looms overhead. To the south is the courtroom block while the offices and other spaces are across Smithe to the north

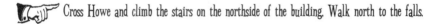 Cross Howe and climb the stairs on the northside of the building. Walk north to the falls.

The stairs just in from Howe Street take you up and away from the traffic and into the lush landscape designed by Cornelia Oberlander, Arthur Erickson's collaborator on many projects including the Museum of Anthropology at UBC. Her design for Robson Square again emphasized native species though the gardeners seemed to have snuck a bit more colour into the flower beds over the years.

At the top of the stairs is the Joy of Freedom, a sculpture commemorating the liberation of Holland by Canadian soldiers in 1945.

The true majesty of Erickson's creation has to be the waterfalls that thunder down and across the building. From the top of the falls the view out over downtown is made for post cards with the Hotel Vancouver and Vancouver Art Gallery, the former courthouse, in the distance.

In the 1960s conditions at the old courthouse were dire and the place was bursting at the seams. A decision was made by the government of the day to replace the building with a fifty storey tower which would be part of a

much larger scheme of redevelopment for downtown; but a change of government meant a change of plans.

The incoming premier looked at the tower model, and the rumour goes, took it and laid it down on the table and suggested this might offer a new way to think about the design. The three block long Robson Square complex is the result. It replaced a rag tag collection of buildings including Danceland, a popular club, and the old CJOR radio studios.

From the waterfalls and the top of the stairs you can look down to the skating rink tucked under Robson Street. The sunken plaza here was originally planned as an entrance to a transit station but plans changed and the proposed underground line never materialized. At this point if you need a break head up the stairs and cross the pedestrian overpass to the courthouse and grab a coffee at the restaurant inside. It offers the most magnificent views out over the whole of Robson Square, the city and the lake which feeds the falls.

 At the multicoloured sculpture, by artist Mike Banwell, head north and take either of the paths to Robson Street, cross Robson and walk to Georgia Street.

The way to Robson Street is through more lush plantings. The path divides, one way is along a trail at the edge of the parking garage exit and the other leads to a grassy knoll before winding down to the street. On the street the 1912 wing of the Art Gallery commands the view. Thomas Hooper designed the addition to the main building and it still contains much of its original grandeur including two original courtrooms; they are popular locations for both film and television. The pediment features a sculpture "Placed Upon the Horizon (Casting Shadows)" by American artist Lawrence Weiner.

As you walk down Hornby compare the architecture of Hooper and Rattenbury, I think you'll find Hooper's composition more refined and better detailed, if nothing else Hooper's lions actually look like lions instead of Rattenbury's angry dogs. The interior of the main building was gutted by Arthur Erickson in a redesign for the art gallery, all that remains is the odd decorated ceiling and the building's central rotunda. The rotunda is a smaller, simpler version of the design used by Rattenbury in the Parliament Buildings in Victoria.

Outside, vestiges of its former use remain with "Police" and "Offices" inscribed in the granite above former entrances and with the "Sheriffs" light on the wall. On the lawn facing Hornby Street is probably one of Vancouver's most vandalized memorials. Poor old Edward Vll. He has to suffer from every budding comedian who thinks they've discovered an original way of using their felt pens to mark up his name which appears below his profile. The fountain is by the sculptor Charles Marega and was a gift from the Imperial Order of the Daughters of the Empire in 1912. It was re-erected in this spot in the 1980s. Take a look at the back of the monument and read the passage from Shakespeare. The other fountain on the site is the Centennial Fountain commemorating the union of the crown colonies of British Columbia and Vancouver Island in 1862. A plaque set into a nearby hedge explains the symbolism found in the carved rocks.

Overlooking the plaza the two granite lions which guard the former entrance to the building are modeled on the lions at the base of Nelson's Column in London's Trafalgar Square. A close inspection of the one to the west reveals a break in the stone where the poor guy's back end had to be replaced after an unexplained explosion in 1942 damaged his hind quarters. After checking the lion out, step back and look up at the roof to see Ken Lum's installation "Four Boats Stranded: Red and White, Black and Yellow" The Art Gallery's press release explains the significance of the work: "Taking into account several important attributes of the Vancouver Art Gallery's site, Ken Lum has created a work that serves as a directional, geographical and historical marker. The four installed boats include scaled down versions of a First Nations Longboat, Captain Vancouver's ship [Discovery], the Komagata Maru (the infamous 1914 Indian immigrant ship) and a cargo ship that recently carried migrants from China's Fujian Province. The boats are each painted a single colour which speaks to a colonial stereotyping of cultural, racial and historical identification. The First Nations boat is red, Captain Vancouver's ship is white, the Komagata Maru is black and the Fujian ghost ship is yellow."

> **SkyTrain Notes:**
> SkyTrain is fully automatic. Staff patrol the trains but the trains themselves are driverless. Computers under the watchful eye of trained operators monitor each train and station.
>
> Information on the speed and position of each train is relayed several times per second to the central control.

Across Georgia Street Vancouver's other venerable hotel is the Georgia. The hotel designed by Garrow and Graham in 1927 (Graham's son was the designer of the 1962 Seattle Worlds Fair icon, the Space Needle) was

once considered a prime development site but luckily a drop in the prop-erty market gave the hotel the time it needed to survive. Today after a sensitive, but thorough, renovation and restoration the hotel remains popular with visitors and residents. The former George V pub downstairs was a favourite UBC student hangout and a regular practice spot for a local barbershop quartet which used the bathroom's acoustic qualities to good effect. Radio station CKWX once broadcast from a studio on the hotel's roof.

The Devonshire Hotel next door was not so lucky and met its fate in 1981 when it was imploded in an early morning blast. The best thing about the building that replaced it is the Alan Storey sculpture in the atrium.

 Walk up to Granville and Georgia to return to the SkyTrain station

On the way to Granville Street as you pass by Pacific Centre's original twin black towers it's hard to imagine today the negative reaction they first generated from the public; so much so that the politicians of the day had the developer make sure the Four Seasons Hotel and Stock Exchange towers were altered in colour and materials.

From here its a short walk down Georgia to Stadium Station for the next tour (walking may be faster given the depth of the Granville station) or stop and find coffee, not hard to do, and rest the feet.

4

Stadium Chinatown Station

S tadium Chinatown Station sits at the edge of the escarpment that surrounds much of the downtown peninsula and is the station before the SkyTrain line goes underground. Vancouver's two sports arenas and Chinatown are close by - hence the station's name.

 Exit by the stairs heading toward Beatty Street, cross Dunsmuir and walk to Georgia.

Directly in front of the station is the striking AMEC building which is cantilevered out over the SkyTrain tunnel. The Beatty Street Drill Hall across Dunsmuir to the south is home to the British Columbia Regiment. The regiment formed in 1883 and is the oldest existing military unit in British Columbia - Major Mathews, the City's tenacious archivist served with the regiment in the 1890s. Prior to its construction in 1900 the regiment met on Pender Street at the foot of Beatty Street in a small wooden building which later became an opera house. The Drill Hall opened to great fan fare with visits from the Duke of Cornwall (the future George V) in 1901. The parade ground where much of the pomp and ceremony took place was across the street on what would become Larwell Park, later the central bus station and now a parking lot awaiting development.

The Drill Hall is surrounded by condominium construction as the empty space around the stadiums is filled in with tower blocks. At the end of the block the remnants of the original Georgia Viaduct, saved when the un-loved 1915 structure was demolished, form a small park. The original viaduct was so badly constructed that a proposed street car line was never instituted because it was feared that the bridge couldn't support the constant rumbling of the street cars. The current viaducts, opened in 1972, are the only pieces of the projected freeway system built before widespread citizen protest stopped everything.

On cold days the steam billowing from Central Steam Heat Distribution's cooling towers makes for an impressive sight. This former printing plant for the two daily newspapers sitting on the southeast corner of Georgia

and Beatty heats most of the major buildings downtown through a seven mile network of pipes under the streets. Gastown's famous steam clock sits atop one of the many vents the system has around the city, however, only the clock's whistles use the steam. The clock itself is powered by electricity.

It's a short walk from the corner to the rear of the steam plant where you'll find the signs for the BC Sports Hall of Fame. It's a museum that documents the sports history of the province and should be visited by more people. Take a look if you have time.

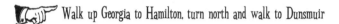 Walk up Georgia to Hamilton, turn north and walk to Dunsmuir

Four civic institutions occupy the corners of Georgia and Hamilton. Prior to the 1950s when construction started on the Queen Elizabeth Theatre and General Post Office the surrounding area was largely populated with wooden houses sitting cheek by jowl on twenty-five foot wide lots. Since the 1930s there had been a number of planning studies suggesting the city needed a civic centre that included such uses as art galleries, theatres, and city hall. Planning continued into the 50s with an ambitious plan for a convention centre, sports hall, theatre, auditorium and civic museum centred on this corner. In the end only the Queen Elizabeth Theatre was built.

The design is the result of a nation-wide open competition won by a team of architectural students and instructors from McGill University. Their design drew heavily on the recently completed Royal Festival Hall in London for inspiration. The QE theatre was officially opened in 1959 with a visit by the Queen. The fountain in the plaza was a gift to Vancouver from the German community in 1971.

On the south side of Georgia is the Paul Merrick designed CBC Building known to staff as "Britannia Mines South" because of the depth of the studios and the design of the office block which recalls the concentrator building at the mine. Opposite the CBC, Moshie Safdie's design for the

central library looks suspiciously like a Roman coliseum, despite what he says. Vancouver residents like their libraries since there is always a crowd at the entrance before opening time in the mornings.

The really big building here is the massive General Post Office which takes up an entire city block between Georgia and Dunsmuir. Construction on this giant started in 1953 and took almost five years to complete. It encompasses fifteen acres of space and was the largest welded steel frame building in the world at the time. McCarter and Nairne's design paid attention to the details. Take a look in the mail box lobby where the architects have used glass panels etched with the crown and fleur-de-lis in the illuminated wall above the mail boxes. A geometric design in aluminum runs along the top of the mail boxes and is lit from above. The floor is in green, white and black terrazzo and the tables in the lobby are black granite. During the day the full height, south facing windows illuminate the lobby while at night the effect was reversed; the lighting scheme brought the lobby into full view from the street. Art work is throughout the building, the most prominent is the relief sculpture of a postman at the entrance to the mail box lobby by Paul Huba.

SkyTrain Notes:
SkyTrain is the world's longest automated light rail rapid transit system. With the construction of the Millennium line there are now 32 stations on the system.

Trains run every two to eight minutes at an average speed of 40 kph.

The exterior of the post office has recently had extensive work done on it including the restoration of the original colour scheme. At the top of the building the administration offices are in a separate four storey block on the roof which is really the base of a proposed office tower that was never built.

On the northwest corner of Dunsmuir and Hamilton, the new BC Hydro building is far less interesting than their inspired former home at Nelson and Burrard. The Delmar Hotel is just visible behind the landscaped plaza. The owner of this small Edwardian hotel was not interested in selling the building for development and remained defiant; the text above the gallery entrance - by artist Kathryn Walter - sums up the situation rather well. The Hydro building occupies the site of the Alcazar Hotel and the Coffee Club restaurant which was decorated with early Jack Shadbolt murals which were lost in the demolition. Shadbolt taught at the Vancouver School of Art (originally the Vancouver School of Decorative and Applied Arts) across the street along with noted artists B.C. Binning and F.H. Varley.

 Walk down Hamilton to Hastings Street through Victory Square.

Between Pender and Hastings the City's engineering department have reset the original granite pavers of Hamilton to restore the appearance of the early street.

At Pender Street you step back into the old city. At the top of Victory Square the view across the park to the north is of the dramatic roof, orange terra cotta and red brick of the 1909 Dominion Building. When it was built it was Vancouver's first steel framed "cloudscraper" and the tallest building in the British Empire. To the east is the Richardsonian-Romanesque of the Flack Block, built by Thomas Flack from the proceeds of the Klondike Gold Rush. Above the Flack Block sits the big red W of the former Woodwards department. On the eastern edge of the park the Carter-Cotton Building was home to the News Advertiser and later the Vancouver Province newspapers. The building across the lane but connected by a third floor bridge was the paper's printing plant but has been renovated as offices for the Architectural Institute of BC.

Swing around and look across Pender to the south of the park; the view is of the Vancouver Community College an early example of the International Style designed by Sharp & Thompson, Berwick, Pratt in 1948. At the turn-of-the-twentieth-century the site was occupied by the 1891 Central High School one of three schools constructed that year that included the East End and West End Schools. (The West End derives its name from the school, just as what is now Strathcona was known, until quite recently, as the East End, after the school.)

In complete contrast to VCC's crisp exterior is the rough stone work of the former Lyric Theatre and Odd Fellows Hall across Hamilton. Built in 1906 the building accommodated the theatre downstairs while Odd Fellows met upstairs. Unfortunately the building has suffered a few indignities over the years including the loss of its cornice. At the corner of the building you can still see, despite the crumbling sandstone, the Odd Fellows' three linked chains that symbolize friendship, love and truth.

From Hastings and Cambie walk east on Hastings to Abbott, turn south and walk to Pender, turn east and walk to the Chinatown Gate at Shanghai Alley.

Until relatively recently Hastings Street was one of the main shopping streets for Vancouver. A number of factors have contributed to its decline including, the long lasting affects of the closing of the BC Electric Interurban station at Hastings and Carrall in the 1950s (the cessation of interurban service took an estimated 10,000 pedestrians a day off the streets), the continuous westward shift of the downtown in the 1970s and 80s and the closing of the Woodwards department store in 1992.

The Woodwards building dominates the block between Abbott and Cambie. Though it started out as a modest three storey structure in 1903, Charles Woodward the store's founder, quickly added to the building in 1908 and followed with further additions, eventually there were fourteen separate additions to the building. On top of it all is the store's water tower and former peanut butter factory (the store was famous for its brand of peanut butter), on top of this sits the 1927 replica of the Eiffel Tower and on top of this sits a six thousand pound big red W. It used to rotate six times a minute and was lit with red neon and a few thousand white light bulbs. The City designated the W in the 1990s as a heritage resource.

Two years after Charles Woodward opened his store, Mr Bancroft opened the Bismark Cafe in the block facing the store. His restaurant was pretty deluxe, with a full orchestra, seating for over a hundred guests, private dining rooms for ladies and an electric fountain. Also in the block was White Lunch No. 1 of the local and popular chain of cafeterias. Beside the restaurants, the block itself is a remarkable collection of buildings from the late nineteenth and early twentieth century. The 1899 Ralph Block at 126 West Hastings is interesting for its use of cast iron in the facade and the Regent Place Hotel, the twenty-five foot wide building towering over the rest of the block was once home to the Vancouver Stock Exchange.

At the corner of Abbott and Hastings look to the northeast for a glimpse of the neon "flying" pigs of the Save on Meats store mid-block (the coffee shop at the back of the store serves a good burger).

 Walk to Abbott, cross the street and turn east. Walk to Carrall

On Abbott Street there is an excellent view of the Sun Tower from the east side of the street as you walk up to Pender. The tower built in 1912 to the designs of W.T. Whiteway for L.D. Taylor's Vancouver World newspaper took the "tallest building in the British Empire" title. Of note are the nine voluptuous maidens at the eighth floor.

If you stood on the corner of Abbott and Pender in the 1970s and looked south the view would be significantly different. Where today the view is of new streets, sports arenas, condos and shopping malls, as late as 1978 the area was still heavily industrial. Railway freight yards, warehouses, scrap yards, a bus garage, and even a sawmill would fill the view.

International Village, the shopping and movie complex occupies a good chunk of the former CPR freight yard. All of Pender between Taylor and the buildings on Beatty Street was a busy rail operation until the 1980s. The main circulation space of the mall follows the alignment of the former right-of-way the CPR used to move trains between False Creek and Burrard Inlet until they dug their tunnel under downtown in the 1930s. It's also worth coming back to see the mall building in the evening because of the very good display of neon.

The buildings on the opposite side of Pender were a mix of wholesale operations such as, D.J. Elmer Wholesale Tobacconist, suppliers of Van-Loo, El Sidelo and El Doro cigars at 27 West Pender, and rooming houses and hotels, such as the Arco which takes full advantage of its 25 foot wide lot. Until the 1950s the parking lot on the north side of Pender, opposite the mall, was a hive of activity with street cars and interurban trains coming and going from the BC Electric Railway's main station. High up on the wall of the former station is a modern neon version of Reddy Kilowatt; the BC Electric Company along with power companies across North America used the character to promote electric power and the modern conveniences that came with its use.

The western boundary of Vancouver's historic Chinatown is now marked by the Millennium Gate which spans Pender Street. The gate is a mix of modern and Chinese elements based on historic examples found in China. The gate's architect, Joe Wai, consulted a feng shui master to determine the gate's decorative scheme of musical instruments and women's costumes. Carefully poured and cast concrete is used for the columns and lions at the base. (Rub the lion's forehead for good luck.)

The gate sits in front of the S.U.C.C.E.S.S building which tries to capture in its form the former tenement building which occupied the site until its demolition for a steel company's warehouse. The original tenement, a residential development built by entrepreneur and businessman Yip Sang, had an internal private street known as Canton Alley which the new develop-

ment also echoes. The next street is Shanghai Alley once a busy and active commercial street and home to the Sing Kew opera house but it has been reduced to a shadow of its former self and only two original buildings remain. The alley is often thought of as the birthplace of Chinatown but it was not developed until 1904. At the end of the alley is a reproduction of a West Han Dynasty bell from Guangzhou Province given to Vancouver by the Chinese government. Surrounding the bell are a number of interpretive panels detailing the history of key figures and events in Chinatown.

The Sam Kee building, one of Vancouver's best known landmarks, takes up the south side of Pender between the alley and Carrall Street. Built by Chang Toy for his Sam Kee Company the building is the narrowest commercial building in the world according to Guinness though there is a house in Amsterdam that is narrower by a foot or so.

On the northwest corner of Carrall and Pender is the Chinese Freemasons building of 1901. In the 1920s it was home to the popular, second floor, Peking Teahouse. The building was damaged by fire and was completely rebuilt in the 1970s. In 2005 the building was adapted for seniors' housing. Dr Sun Yat Sen the revolutionary leader visited Vancouver three times on fund raising trips for his bid to overthrow the Qing Dynasty and is said to have stayed at the Freemasons'. Considered the father of modern China he has the nearby Classical Chinese Garden named in his honour.

The Dr Sun Yat Sen Classical Chinese Garden and Chinese Cultural Centre sit on what was once False Creek. The early development in the area was on a short stretch of Pender and along Carrall Street where a number of simple wooden buildings were erected. On the south side of Pender and the east side of Carrall the buildings were on pilings set into the banks of False Creek which came right up along Carrall to Pender. The area was not exclusively Chinese in the beginning; "Chinese Cabins" - tenement buildings not much more than a bunch of narrow buildings divided into tiny rooms mixed with lumber dealers and other businesses.

On Carrall, on the bank of the creek, Frank W. Hart, owner of the city's first silk top hat and the city's first undertaker, opened Hart's Opera House in an old roller rink he'd brought down from Port Moody. (When the Dr Sun Yat Sen Garden started excavations for their extension a number of very early bottles, were found on the site of Hart's establishment.) Later, this early development was swept away for the con-

struction of the Great Northern train station in 1910 which remained until their new station was opened in 1916 near Main Street on the recently filled False Creek flats.

☞ Turn south on Carrall and walk to Keefer turn west and walk to the SkyTrain station.

Take the time to take a stroll up Pender Street through the heart of Chinatown. This is Canada's largest Chinatown and it remains a vibrant and fascinating place to explore. The Dr Sun Yat Sen Chinese Classical Garden, the first full scale classical garden outside of China, was built using only materials brought from China and without using a single nail.

On Keefer the view is of parks and playing fields quite different than the squatters cabins that used to float here on the creek in the 50s and 60s. The condominium project fronting Keefer at the foot of Shanghai Alley is on the site of an early shipyard and the Royal City sawmill.

Keefer ends at the foot of the Keefer Steps that lead up to the station. For a break, there is excellent bubble tea on the food floor in International Village and very good old style Cantonese cooking at Foo's Ho Ho back at the corner of Columbia and Pender.

In Chinatown look for the small signs that look like green ears. These belong to a neat project which brings oral history to your cell phone. When you find one dial the number and follow the instructions. You can also get the stories on the web at www.murmurvancouver.ca.

5

Main Street Science World Station

The station platform sits above the intersection of Main and Terminal. Before heading down to the sidewalk look east past the train station to get an idea of the extent of the original creek basin; everything in your view was once water.

☞ Walk along the platform to exit on the east side of Main Street at Thorton Park. Walk through the park to the front of the station.

Because the Canadian Pacific Railway had been granted the southern Burrard Inlet foreshore for its track, competing railways searched for a convenient route into the city and, more importantly, land for their operations. In 1904 the Vancouver, Westminster & Yukon Railway (later taken over by the Great Northern) brought its tracks down the south shore of False Creek and out on a trestle across the creek to its station and yard on Pender Street in what is now Chinatown. With little room to grow they approached the City of Vancouver in 1909 for permission to fill part of the eastern end of the creek. At the same time the Canadian Northern Pacific (soon to be Canadian National) was requesting the eastern basin for the terminus of its transcontinental line. Once negotiations were complete, filling in of the basin began and was eventually completed in 1916.

The agreement with the Canadian Northern required the railway to construct a station worth at least a million dollars and a downtown hotel of at least 250 rooms - today's Hotel Vancouver was the result (see page 47). The Great Northern also constructed a grand station and the two stood side by side until the 1960s when it was demolished.

Thorton Park, named for the Canadian National Railway's president was developed in the 1920s. Look for the line of trees which used to line National Avenue until the street was filled in to become part of the park. Near the centre of the park is Marker of Change, a quiet Vancouver memorial to the 14 women killed by a gunman on December 6th, 1989, at the l'Ecole Polytechnique, University of Montreal.

The station building itself is a grand neo-classical affair designed by Winnipeg-based architects Pratt & Ross in 1916. The roof top sign was altered from Canadian National to the meaningless Pacific Central (a name concocted when the bus station was moved here in the 1990s). Inside the grand concourse it is a busy place with passengers waiting for Via and Amtrack trains, and a variety of bus services. The bus platform is an interesting, modern, interpretation of the railway platform canopy.

☞ Walk down Station Street to Terminal Avenue, cross Terminal at the light and pick up the continuation of Station Street.

The filled in creek basin provided land for the railway operations and created a whole new industrial district. Neon Products established their factory and offices on the south side of Terminal in the 1930s and had a huge rooftop sign spelling out NEON facing Main Street. The Massey Harris Company had an implement warehouse on the block and Buckerfields Mission Revival building at 250 Terminal, was a warehouse and seed storage operation. At the rear of the Buckerfields building part of a painted sign can still be seen advertising Seeds and Feed.

The east side of Station Street was taken up by Canadian National's freight sheds which ran along Terminal Avenue and the Vivian Diesels and Munitions Ltd. The Vivian diesel engine was developed by the Vivian brothers whose family were pioneers in the Killarney neighbourhood of South Vancouver. Their engines powered tug boats, yachts and provided power for many small communities. In 1950 the company was acquired by British interests. The site today is taken up by the Angiotech International building constructed in 2002. Sprint Canada's decidedly modern build-

ing at the corner replaced the Morrow Ice and Fuel Company. Morrow Ice will be remembered for their slogan "Call to Morrow for ice today".

The opposite side of the street was occupied by a jam factory for Hedlunds Ltd and the Canadian Boxes Ltd factory. The streets names here are quite straight forward; Northern, Southern and Western are their positions on the property and Central Street was in the centre between Northern and Southern.

 Walk to Industrial Avenue, turn west and walk to Main Street.

Number 281 Industrial looks like it has some architectural interest until a closer inspection reveals that most of it is a stage set for a props rental firm. On the opposite side of the street the BC Tractor Equipment Company took up the the entire south side with their office, storage and repair facilities.

At Main the street jogs as it runs north towards Terminal Avenue, this is where the creek was at its narrowest and its where the bridge was constructed to connect the early city with the road to New Westminster. The first bridge was in 1872 and the last was a bascule bridge erected in 1908 by the City when the eastern creek basin was still considered for a possible deepsea harbour and docks. Across Main Street close to the site of the Loomis Art store was the City Market building. This fantastic vision of glass and turned wood sat on pilings out over False Creek, its entrance with its twin towers and large arched glass window recalled a Victorian railway station. Delightful as the design by W.T. Whiteway was the building was not a financial success and it was consumed by fire in the 1920s.

Turn south and walk to 2nd Avenue and cross at the lights. Turn east and walk to Scotia Street.

On the slope east of Main Street, the City of Vancouver has tried a unique zoning which allows the construction of artist livework spaces. Many of the buildings evoke an industrial esthetic with metal siding and primary colours like 1850 East Second on the corner of Lorne. Lorne Street was home to W.H. Chow a builder, contractor and one of the very few Chinese Canadians to gain professional accreditation as an architect. His buildings were primarily in Chinatown and Mount Pleasant and he collaborated with architect W.T. Whiteway in the 1920s on a couple of commissions.

On Scotia Street the three Edwardian houses at 1905, 1913 and 1919 are typical of the types of houses Chow would be building for his clients. 1907 Scotia has been "topped" and lost its roof at some point in its history. At the corner of 4th and Scotia the red house at 273 4th, home of Cleary family, is one of only two houses left on the street. George Howard at 296 4th, whose house features a turret, was his neighbour.

The original names for the streets in the area, Dufferin, Lorne and Lansdowne, were named for Canada's Governor Generals.

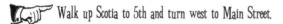 Walk up Scotia to 5th and turn west to Main Street.

The traditional Northwest Coast longhouse form has been adapted to provide an inspirational building which houses the Native Education Centre at 285 East 5th The building, constructed in 1985, has a ceremonial entrance totem carved by the Nishga master carver Norman Tait. The centre, a private post secondary institution, is affiliated with Vancouver Community College. The gardens that surround the building have been planted in native species. The 1888 Clark house, one of the oldest houses in the city, used to sit next to the Centre however it was moved to 10th Avenue between Manitoba and Columbia in 2003 to become part of an infill development.

On the opposite side of Scotia, the large artist livework building occupies the site of the dairy and ice plant established by dairyman Sam Garvin who pastured his cows nearby. At the end of his 5th Avenue property was Brewery Creek which was still open in the 1930s. The creek gave rise to a number of businesses in Mount Pleasant, the largest being the Doring and Marstrand Brewery at 6th and Scotia. The garage at the northeast corner of 5th and Main was originally for Neon Products' truck and equipment storage.

Cross at the light and walk down 5th to Ontario, turn north and walk to 2nd Avenue.

West of main Street the slope south of False Creek quickly developed into a residential district with a scattering of businesses near the water's edge but in the 1930s the City zoned the south shore for industry. As you walk to Ontario, look up to the roof of the building at the southwest corner of 5th and Quebec to see the amazing stack of automobile bumpers.

Many of the trends popular in architecture also turn up in industrial buildings, take note of the Art Deco details which show up along the top of the N. Jefferson Company at the southeast corner of 5th and Ontario. A strik-

ing modern warehouse that features a cantilevered glass box on the second floor takes up the southwest corner of Ontario and 4th. Just past the lighting company on 4th Avenue is the former Salvation Army building which has undergone a renovation and has had its brickwork stripped of the nasty green paint and had its cornice re-established. Opposite the lighting company, the former Empire Cleaners hums and spits at all hours of the day getting the city's laundry done.

Detour: The area has a distinct industrial feel to it but not too long ago this was a neighbourhood of houses and apartment buildings. Today there are still a number of residents who live on the south slope.

Walk up Ontario to 6th to see a collection of houses which give a good impression of how the neighbourhood once looked.

On weekday mornings the block between 2nd and 3rd is an informal job market where prospective employees wait patiently for someone to drive by and offer them a day's work. This odd little slice of life happens because the government employment office was at the corner of 2nd and Ontario until it closed over fifteen years ago. However the practice of waiting outside for an employer continues. The International Junk Company operated from a building on this site in the 1940s.

☞ Cross 2nd at the light and walk to 1st Avenue. Cross 1st and walk along the bike path to the edge of the creek and follow the walkway to Science world and the SkyTrain station.

Look across 2nd Avenue. At the crosswalk the yellow auto body shop, the former home of an aluminum foundry, shows a little bit of style with its spare use of Art Deco elements.

From the same vantage point at 2nd you can see the huge red wood framed Opsal Steel building (originally built for the Columbia Block and Tool Company in 1918) to the northeast. This is one of the very few traditional warehouse/factory buildings left in the city. Its future has been the subject of much discussion over the years though at the time of writing a scheme has been proposed for its retention.

The view from 1st Avenue and Ontario is much different now than it was in the 1960s and 70s when the creek was home to sawmills, shingle mills, shipyards, and a whole raft of other industries. This heavy industrial activity polluted the creek to a point where many believed the waterway was doomed and that it should be filled-in completely; one enterprising candidate for city council suggested, once filled, it might make a good

A short detour: Heading west a block on 2nd, brings you to 172 West 2nd the wonderful and colourful Streamline building originally home to the Automatic Electric Ltd. Note the entrances and how the classical column has been incorporated into the more modern design. A recent paint scheme has highlighted the many details of this building.

expressway through the downtown. What has happened is much better. Industry has been replaced with waterfront walkways, residential districts and the creek is now a valued part of the city. False Creek, by pthe way, got its name from a notation made on a map by one of Captain Vancouver's crew who thought the body of water might be a river but turned out to be a "false creek."

The southeast False Creek area where you are walking is about to be transformed by an ambitious plan that will provide residential, retail and commercial space, and a continuation of the waterfront walkway, sweeping away the last vestiges of its industrial past.

At the foot of Ontario was the Butler & McDougall Shingle Company's mill operation. The Vancouver Salt Company used the red building to the east which sat at the edge of the Sauder Lumber Company operation. The Salt building was built on piles on the edge of the creek; today the building is surrounded by landfill but still sits over a small piece of the creek that can be seen under its eastern edge. Other industry included the Excelsior Paper Company and an asphalt roofing company at the foot of Quebec.

It wasn't until the 1970's that Quebec Street extended past 1st Avenue as part of the abandoned plan for a freeway system; meaning that the properties on Main Street up to Georgia were once all on the waterfront. Not that this was accessible as Main Street was just as industrial as 1st Avenue with stone contractors, coal merchants, cement and building suppliers among the many firms that used the creek.

Today Science World, recently renamed Telusphere, built for the 1986 world's fair, sits at the end of the creek and is the terminal for the Downtown Historic Railway which is owned by the City and uses two restored streetcars to run from the eastern end of the creek to Granville Island in the summer months. It is staffed by volunteers from the Transit Museum Society. The car barn for the two historic trams sits at Ontario and 1st and they use track that once shifted components for the Burrard Bridge and lots of lumber and shingles. Between Main and Quebec on 1st Avenue is the factory for Intermeccanica, since 1982 this tiny factory has been

turning out the well respected Roadster, a reproduction of Porsche's 1959 356A Convertible "D" ,which has buyers from around the world.

At Quebec and Terminal Avenue the condominium towers to the north are part of the City Gate development and sit on the site of Champion & White, building contractors, who helped build much of the early city and are subjects of a well known historic photograph showing one of their horse drawn wagons in the wilds of Kitsilano stuck up to its hubs in mud. Much of the area encompassed by this walk will change dramatically in the coming years and not much of the industrial landscape will remain.

There is excellent Italian ice cream at Ist and Quebec if you're looking for refreshment before heading for the SkyTrain.

6

Broadway Station

Broadway and Commercial Drive is the meeting point for two SkyTrain lines. The original Expo line is above ground on the elevated guideway while the Millennium line is below grade in the Grandview Cut. Its a good opportunity to compare the differences in station design between the two lines. The Expo line stations were all built from a standardized kit of parts designed by Alan Parker and Associates while the Millennium line stations are the creations of a number of architects.

Here the station development has included the redevelopment of the northwest corner of Broadway and Commercial to provide an interchange between the two lines, the B-line express buses and local services.

 Exit the station to the north side of Broadway. turn north on Commercial and walk to 7th Avenue. Turn east on 7th.

The new Commercial Drive station sits in the Grandview Cut, a man-made feature, excavated by the Great Northern Railway in 1913 to lessen the grade of its tracks into Vancouver. Today both Canadian National, Via Rail, Amtrack and Burlington Northern Santa Fe trains share the mile long cut with the SkyTrain's Millennium line. The soil and rock from the cut was used to fill a portion of the eastern basin of False Creek.

Commercial Drive was once known as Park Drive because it ran from Hastings Street out to the parkland given to the city by E.J. Clark in 1889. The land at today's 14th and Commercial was out in the middle of nowhere but Clark hoped his gift might spur development in the area where he maintained real estate holdings. In 1891 the construction of the Interurban rail line to New Westminster, which ran along Park Drive before turning at 14th, helped spur interest in the area. But the arrival of water service in the early 1900s really got things going.

The block of 7th east of Commercial has a wonderful variety of house styles, shapes and sizes giving you a very good idea of how the early city

developed - not by some well organized plan but lot by lot by individual builders. The 1908 directory noted that 7th Avenue was not open between Commercial and Semlin but by 1910 house builders were at work and by 1912 the street was pretty much filled in with houses.

Just in from Commercial, at the lane, Contractor A. Steoff built a very nice variation of the Edwardian Box style with four houses at 1733, 1737, 1743 and 1749 in 1910/11. The houses cost two thousand dollars each, about average for a house of this size, and feature cut out brackets under the eaves and interesting porch columns.

Number 1737 is the most original of the quartet. Opposite these four originals, on the south side of the street, some new duplexes fit in well using the Craftsman style. Next to them are three small bungalows with hipped roofs which look similar but were built with subtle variations. There are a number of cottages on this block of 7th which follow the same general plan. 1765 and 1768 7th are Craftsman bungalows from 1914 by the builders, Farley and Cromie. They must have had an up to date book of plans because they've incorporated the fashionable split verge board into their houses - the design element was showing up in California bungalows at the time.

Chinese builder M.E. Wing, who built a large number of homes in the area before the First World War, is responsible for 1801 7th. Wing was one of a number of Chinese home builders in the city who included S.J. Wing and W.H. Chow, (see pg 49) The plan book came out again when contractor F. Mellor constructed 1813 7th in 1911. The house and its steep pitched roof, dormers, and inset porch was a very popular style in Vancouver and many builders put them up.

In the middle of the block, a sure sign the neighbourhood was populated, is the church. Our Lady of Hungary Catholic Church started life as Trinity Methodist in 1911 then after the Methodist Church, the Congregational Union of Canada, and when seventy per cent of the Presbyterian Church in

Canada formed the United Church of Canada it became, naturally, Trinity United in 1925. The builder A.L. Ramage built the church using elements of the Craftsman style in its design and at the same time built the Edwardian Box style house next door. By 1930 a gymnasium and church hall had been added to the property.

Before leaving the block look at 1851 7th a Craftsman house where only the dormer with its painted out window give you a clue to its design. Of interest is its foundation which is made up of precast concrete blocks meant to look like dressed stone (there are a number of homes in the Lower Mainland which used the blocks for the whole house, not just the foundation).

☞ Cross Victoria Drive, stop and look across the road before continuing up 7th Avenue to Semlin.

At the top of the block, 2313 Victoria Drive is a large house with twin turrets built for Walter Wolfenden, secretary of the Columbia Paper Company. Wolfenden's house is one of many grand homes along Victoria Drive, a result of the Vancouver Improvement Company's promotion of the Grandview area as an exclusive neighbourhood. But when the CPR's Shaughnessy Heights subdivision, with its large lots and real exclusivity, opened in 1909 even some folks who had already built here moved west. Next door an infill house has tried to fit in by copying the turret feature of the main house.

Across the street, on the northeast corner of Victoria and 7th the 1980s Postmodern duplexes are still quite attractive - a darker palette of colours has certainly helped - and they provide quite a contrast to the unassuming Pyramid bungalow next door at 1923 7th.

Across the street at 1932 7th the English Revival style shows up in this house from the late 1920s with its asphalt shingles rolled over the eaves in an imitation of a thatched roof. (see pg 104) It was a style quite popular with Vancouver builders especially on the west side of the city in neighbourhoods like Dunbar. It shows up on the east side usually tucked into older streets like this where builders filled in the lots left vacant after the collapse of the building boom in the 1912 depression.

1936 and 1938 7th are two little Craftsman bungalows, two doors down

on the same side of the street, 1958 7th, the large Craftsman, has a clipped gable roof which is sometimes referred to as a jerkin head. The style of roof is actually medieval in origin but was revived by architects in the late nineteenth century. A jerkin is a short, sleeveless jacket worn in the medieval period - how this became the name for a roof is unclear. This house plan was popular in the United States and Canada where a number of examples are included on heritage registers.

The quirks in a subdivision plan can lead to some interesting developments. For whatever reason, in the original survey of the block two narrow lots were created where there should have been one and 1962 7th is the delightful response to the situation. It is in complete contrast to the two tall 1910 homes across the street at 1957 and 1963 7th built by contractor J.A. Chisolm.

Next door to Chisolm's two houses, the California Bungalow Construction Company, based in Vancouver, built three lovely little bungalow cottages of which two survive at 1969 7th and, just around the corner, 2233 Semlin. Unfortunately the third, 1975 7th at the corner, met the bulldozer sometime ago. These attractive little houses are what the architecture dictionaries mean when they say: "The typical bungalow, a one or one-and-a-half home, with an open floor plan and front porch, was a revolutionary step away from the fussy Victorian floor plan. The typical bungalow featured a deep porch incorporated under a wide, overhanging roof; a long, low profile, and simple interior with lots of built-in cupboards and nooks. There usually were two bedrooms, one bath, a small kitchen and an unfinished basement and upper expansion space. Emphasis on a low profile with most living spaces on the first floor, exposed structural members and wood joinery."

Companies like the California Bungalow Construction Company and the Bungalow Building & Finance Company (they built 1949 7th in 1912) were eager to promote the bungalow way of life. They built the houses and offered the financing too, allowing folks who would not normally be able to afford a home to purchase one on an installment plan.

 Walk to Semlin and turn north Walk to 6th Avenue.

At the southeast corner of 6th and Semlin is an attractive house, though the porch has been filled in. Interestingly in 1911, A.L. Ramage, the builder,

Detour: Just east of Semlin is a block of lovely English Revival homes all dating from the late 1920s and early 30s. Look for a variety of features which distinguish this style such as the Gothic arched entrance, flared walls, leaded glass and the prominent front gable.

Note too the consistant set back from the street, a result of early residential zoning bylaws.

was given a building permit for this property for a framed dwelling for temporary use. The house is quite similar to a house built a few blocks away on Lakewood by contractor James Ball in 1909. Across the street at 2146 6th Charles Kilpin, carpenter and house builder, built this large Craftsman for his family. They would have had spectacular views out across the city and to the mountains. One of his sons, Charles jr., worked as a clerk for the Calladine Grocery.

Calladine's was a small chain of three grocery stores on Commercial Drive, Granville Street and Main. The Calladine brothers lived in the Allan Block at 4th and Commercial while their mum lived nearby. Local historian Claude Douglas remembers the shops as: "sawdust covered floors, great sacks of meal, potatoes, sugar and beans... great rounds of cheeses, so mellow. All shepherded by clerks in chaste white aprons." The stores were of the type where the clerk fetched your order from shelves behind the cash counter while you waited. It wasn't until 1916 when Charles Saunders opened the first Piggly Wiggly self-serving store in Memphis Tennessee that the grocery store as we know it came into being. In 1917 Saunders patented the "Self-Serving Store" idea. Piggly Wiggly stores in Vancouver were the predecessor to Safeways which purchased the chain's West Coast stores in 1936.

Next door to the Kilpin's is another big Craftsman house built the year before by contractor S. McLellan for the Barker Family. In 1916, at the age of forty-four, Christopher Barker enlisted and went overseas with the Canadian Overseas Expeditionary Force in the Canadian Engineers, leaving his wife Elizabeth at home.

McLellan was busy on the street because in the same year he constructed the Barker's large house he was also working on the three houses across the street in the next block at 2033, 2041 and 2049 Semlin. Across the lane from Barker's, house builder Charles Smith was responsible for the four substantial homes there, Eric Bellman, the Merchants Carthage Company's book keeper, lived at 2120 Semlin. (The Merchants Cartage Company was based in the Beacon Hill neighbourhood, near the PNE.)

It's surprising that the area around Semlin Drive did not have a "Heights" attached to it by one of the real estate operators, the idea had become

quite popular with the success of the Shaughnessy Heights subdivision. Quickly all sorts of places became a "Heights" overnight to try and cash in on the Shaughnessy cache.

Many of the streets in the area did not develop as quickly as 7th Avenue; in 1912 there were only six houses on the block of 5th Avenue between Semlin and Victoria. In the block directly east there were just two.

Builder J.G. Barker built the Craftsman bungalow at 1950 5th Avenue in 1912, look to the side to see the wonderful roof line and brackets. 1942 5th Avenue next door, is an interesting house hiding under vinyl siding, its steep roof and flat top indicate an early house. At the end of the block, 1923 5th Avenue was the home of W.J. Gernaey in 1923 who would have enjoyed the large sleeping porch off the bedroom on the second floor.

 Cross Victoria at the cross walk. Walk across McSpadden Park to 5th and Bauer Street.

In 1910 the charter of the dormant Vancouver, Fraser Valley and Southern Railway was acquired by the BC Electric to facilitate the building of their Burnaby Lake Line running between the New Westminster depot on Columbia Street to 6th Avenue and Commercial Drive in Vancouver. The new line ran from the 6th Avenue station on a diagonal to 2nd and Victoria and then to 1st before heading out to New Westminster - the modern care home at 1800 5th Avenue sits on top of the old right-of-way.

The excitement over inauguration of streetcar service along Commercial Drive in 1891 must have influenced William Bauer when he subdivided his property (bounded by 6th, 3rd, Commercial and Victoria) in 1894, since he named the three new streets Electric Avenue (4th), Tram Avenue (McSpadden) and Railway Avenue (5th). Unfortunately the names didn't last very long - too bad, who wouldn't love to live on Electric Avenue - and they took on the name of the street they were closest to on the existing grid. Tram Avenue didn't fit so it became McSpadden Avenue after Col. George McSpadden who among other things was an alderman, city building inspector, and, in 1912, commander of the Irish Fusileers in Canada. The one block long Bauer Street appeared when McSpadden Park was created after the last BC Electric train made its run along the Burnaby Lake Line in 1953.

5th Avenue and McSpadden both have an eclectic mix of houses on them, while there is renovation going on and there are some new Craftsman-

inspired duplexes at the corner of Bauer and 5th, the charm here is in decidedly unrestored look of the streets, the gardens and the people you meet while walking here.

Out on the "Drive" the many three storey walk up apartments, built because of the streetcar line, are evident. The Highland Apartments (Allan Apartments) at the corner of 4th Avenue and Commercial is the most elegant and was built to appeal to tenants such as insurance agent Joseph Hill and the previously mentioned Calladine brothers. What is interesting is the substantial wooden cornice that still graces the top of the building.

SkyTrain Notes:
The Expo line was constructed using 1000 concrete beams each weighing in at 100 tons each. They were precast in Richmond and hauled to the construction site on specially designed trucks.

The beams were moved at night to avoid the traffic.

Look up a block at the southwest corner of 3rd and Commercial to see the former premises of Grandview Motors. It remains as an example of an early style of garage, once common, where the automobiles pulled in under the canopy to get pump service. Commercial Drive the traditional home of Vancouver's Italian and Portuguese communities has now evolved into a diverse and multicultural street.

☞ Cross Commercial at the crosswalk below 4th Avenue. Walk part way down 4th Avenue.

The curious building apartment at 1644/52 4th Avenue, just west of Commercial, with its deep balconies dates from 1912. In the 1930s the City zoned the west side of Commercial as an apartment district but it took until the 1970s before the majority of buildings were built and even with the zoning many fine houses still survive. An excellent house, full of detail, can be seen at 1656 4th Avenue. The decorative fretwork on the verge boards is wonderful and rare - so many times this delicate work gets damaged and does not get replaced.

Farther down the block residents would have been in the shadow of the Vancouver Gas Company's two gasometers - storage towers for natural gas - at 4th Avenue and McLean Drive. Whether by design or fluke the apartment towers built on the site are about the same scale and colour as the structures they replaced. Just a block away from the gas company at 4th and Woodland was Grandview School. Opened in 1905 (the current building was constructed in 1926) the school continues to play a strong

role in the community with its innovative First Nations Program "developed to increase awareness and sensitivity to First Nations culture and history as well as to provide students with increased confidence, self-esteem, and pride". A portion of the school grounds are landscaped to provide space for a butterfly garden, community garden, and an ethnobotanical garden of plants traditionally used by First Nations.

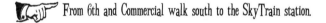 Walk back to Commercial Drive turn south and walk to 5th Turn west and walk to the lane. Walk south in the lane to 6th Avenue.

1670 5th Avenue, the handsome bungalow in the Craftsman style was home tocarpenter Rooserick McCrae in the 1920s. There is a nicely detailed garage in the lane with some panelled doors which is worth a look. It sits next to a small house (addressed as 1662 5th Avenue) at the rear of the main house.

Bowling alleys were once a common sight in most Vancouver neighbourhoods but today they have pretty much disappeared. Since 1947 five pin bowling has found a home on the Drive at Grandview Lanes, 6th and Commercial, run by the third generation of the Marino Family. Granview Lanes also has one of the last original neon ceilings left in the city; its pink and white bowling ball and pins hover over the tables in the coffee shop. Neon was once a popular lighting source, not only for signs but interiors as well and many establishments used neon as their sole source of light.

From 6th and Commercial walk south to the SkyTrain station.

There are numerous restaurants and coffee shops in the area to grab refreshment from. The coffee shop on the southeast corner of 6th and Commercial was the home to Continental Coffee one of the few places in the city where good beans could be found before the current explosion in stylish coffee. It sits opposite the 1960s era post office building on the site of the BC Electric interurban station.

7

Nanaimo Station

N anaimo Station is between the Gladstone and Beaconsfield stations on the original BCER line to New Westminster. Settlement out here was sparse in the early years, apart from a few farmers and nursery men the only noticeable presence was the Vancouver Pipe & Foundry Company roughly where today's SkyTrain station is. George Morton along with four of the foundry's workers; George Cox, John Young, Charles Paepke and William Perskin, lived nearby. In 1911 stonemasons John and William Fraser, carpenters William Bright, William McKnott, and John Smythe joined the foundry employees as the only other residents out here.

At the time, the city boundary was at Nanaimo and east of that was the Hastings Town Site, a reserve set aside by the colonial government in 1863, which wouldn't become part of the city until 1911 when the few residents living there voted overwhelmingly to join Vancouver. The major settlement was farther east at Collingwood, centred around Joyce and Kingsway.

The streets in the neighbourhood are named for British Columbia towns and cities.

👉 Leave the station and walk around the bus loop to 24th Avenue and walk to Kamloops.

In the 1920s the bush started just east of Kamloops Street near the home of Joshua Brabbins (2523 24th Avenue). his only neighbours on the street were auto mechanic J.H. McKenzie (2473 24th Avenue) and Wasil Pidruczny (2443 24th Avenue), a moulder, who it is presumed, worked at the foundry across the road from his home. In the late 1940s and early 1950s a number of new homes were constructed in the area. These new bungalows were modest but well designed homes as evidenced by the intact example at 2506 24th Avenue.

👉 Turn south on Kamloops. Walk to 25th and follow 25th to Kaslo.

The majority of the homes in this block of Kamloops were built prior to World War One but they look like they're just waiting for the bulldozer. (One of the difficulties in writing about an area such as this is the amount of demolition that can take place over a short period of time and where nice solid mid-century homes are there one day and gone the next. As you walk this tour you can't miss seeing the "new home coming" signs from local builders.)

At the corner of 25th and Kamloops look for the date (1950) and the original street name (E. King Edward Ave) stamped into the corner of the sidewalk. On the block there are a few older homes hanging on. At the corner 2507 25th Avenue was the home to bricklayer David Farlow while his brother had the house across the street at 2550 25th Avenue, which has seen a few renovations in its life. It was then bush all the way to Slocan.

Until development in the 1940s and 50s started to eliminate them, the area still had creeks and streams that fed Trout Lake. The lay of the land can give you sense of where many of the creeks were; at Penticton at 25th the road drops to the north on roughly the route of a creek which started somewhere near Slocan and Vanness. If you listen at certain manholes in the streets you can hear the sound of rushing water which is probably one of the early creeks running in a buried culvert.

The 2600 block of 25th Avenue was developed pretty much all at once in the 1970s. The homes are examples of the Contractor Modern style featuring double height "cathedral" entrances, and non traditional roof lines. 2615 and 2623 25th Avenue two are great examples of this style. Their roots are in the suburban home developed after the Second World War in massive tract developments such as Lakewood, California and Forest Hills, Illinois where mass production techniques were brought to house construction. No longer were individual builders working piecemeal in the cleared forest, it was crews of men building streets all at once.

In the centre of the block, on the north side, are examples of the traditional Vancouver Special with its shallow pitched roof and narrow front balcony. Across the street the Contractor Moderns take advantage of the larger lot sizes on that side of the street; they wouldn't seem out of place in the subdivisions of Richmond or Burnaby. At the end of the block, at the lane, 2683 and 2691 25th Avenue are a different variation on the Special.

From the corner of Slocan and 25th there's an excellent view back over the downtown; it's a wonder why areas like this haven't been more sought after given the spectacular vistas out over the city, Burrard Inlet and mountains there are from the east side. Before crossing Slocan take a short detour north on Slocan to look at 4035 Slocan, an English Revival house with some interesting details. Look for the home's rounded corners and brick gothic arch at the front door.

 Cross Slocan

Because the Beaconsfield stop on the old Interurban was very close by, the streets east of Slocan developed earlier than other parts of the neighbourhood. It's the same pattern over and over. Development follows transit and even today we see the results of increased development sprouting up around the Skytrain stations.

On 25th, the home of Royal Dairy employee William Hooper remains at 2721 25th Avenue, albeit with some renovation over the years. The small bungalow with the English Revival details- note the flared walls of the house and porch - was built in the 1940s. The flared wall was an allusion to stone construction. More modern neighbours are the split roof Vancouver Specials at 2734 and 2765 25 Avenue with clerestory windows providing additional light for the house.

At the corner of Kaslo and 25th its hard not to miss the impressive view north to the mountains.

 Turn north on Kaslo, walk to 24th Avenue and turn up 24th to the lane. Turn north at the lane and walk to 23rd.

The steep roof of the unassuming house at 4065 Kaslo gives an indication that the building might be older than it appears. It was originally the

Sunday School for beaconsfield United Church (see pg 71). Across the street the Craftsman bungalow at 4016 Kaslo was home to meat cutter A.J. Banham. The 1950s bungalow next door (4010 Kaslo) shows a bit of style with the glass block surrounding the front door, showing that builders liked to keep up with trends in design.

Trying to keep up appearances has lead to the renovation of the house at the corner of 24th and Kaslo. Originally built in 1925, the home has been enlarged over the years but the roof line of the original house still manages to point to the houses's age. Around the

> SkyTrain Notes:
> The Expo line had 114 train cars arranged in two and four car sets. The system carried over 90,000 people on an average weekday in 1990. Today with both lines the system carries 34 million people a year.

corner on 24th the street ends with the forest of the Renfrew Ravine which stretches from 29th Avenue to 22nd Avenue, after 22nd the forest has been tamed into a park but Still Creek, which runs through the ravine, remains open for its entire length far into Burnaby.

On the southeast corner of 23rd Avenue and Kaslo, 3906 Kaslo is a well kept Craftsman bungalow of the 1920s. It is very typical of the modest homes many builders were constucting for new homeowners. These basic bungalows, based on the Arts & Crafts principles, were "cozy" and featured compact floor plans with little wasted space for such things as hallways. Here the builder has enlivened the front with the split verge board design.

 At 23rd walk west to Slocan. Cross Slocan and turn south and walk to 24th. Turn west and walk to Penticton.

The 2700 block of 23rd has a variety of stlyes including the very nice, intact, bungalow from 1948 at 2773 23rd Avenue. A similar bungalow of the same date survives at the end of the block at 2717 23rd.

On the southwest corner of Slocan and 23rd, 3915 Slocan, built in the 1940s, presents an English Revival face to the street with its prominent chimney and gable. Unfortunately it is homes like these which are very often bulldozer bait in Vancouver's neighbourhoods; replaced by ersatz Craftsman construction.

Before heading to 24th, walk down 23rd to 2668/70 23rd Avenue to see the curious duplex with its odd roof line from the late 1940s.

The 2600 block of 24th is one block of nothing but Vancouver Specials all built in 1972. This much maligned house style is an efficient use of land, cheap to build (the shallow roof line is the maximum slope you can still use a tar and gravel roof on), easy to maintain and not as bad as commentators and urban critics make them out to be. In fact most efforts to improve on the basic Special through zoning and design guidelines have led to the many nasty ill-proportioned home designs Vancouver's neighbourhoods get stuck with today. In its basic form the Special was a response to zoning by maximizing the allowable building envelope and floor space, and it was adaptable to various lot sizes, as can be seen on this street. Decorative schemes are quite varied with different railing designs for the balcony, brick and stone on the lower levels and a variety of trim details. It had a long run in the city with the first examples being built in the early 1960s and the last in the early 1980s when the zoning bylaws changed.

At Penticton and 24th, 3925 Penticton and its neighbour acoss the street are examples of a late 1950s split-level or raised ranch house. The split-level is a variation of the original low one floor ranch house which puts the bedrooms and bathrooms in the raised portion, usually over a garage, while kitchen, dining and living rooms are on the lower level. The two houses here are quite small versions of the style.

 Walk down Penticton to 23rd. Turn west and walk to Nanaimo.

Along 23rd a few early houses exist among the more modern styles such as Northwest Messenger and Transport Company driver Rhubsu Philip's Crafts-man house at 2547 23rd Avenue; its original shingles can be seen down the side of the house. The 1980s era house at 2535 23rd Avenue with its beams and double height ceilings wouldn't look out of place in Richmond and stands in contrast to the modest 1950s bungalow at 2525 23rd Avenue.

In the next block the big Craftsman/English Revival home at 2425 23rd Aveune was built in 1930 and its clipped gables and double dormers give it a commanding presence on the street. Alex Carp's neighbour lived in a similar styled home across the street.

 Walk south down the lane to 24th Avenue and the Skytrain Station.

8

29th Avenue Station

T he 29th Avenue Station is in between the old BCER Interurban stops Beaconsfield and Earles Road. Early development was grouped around both stations where stores, a post office and houses were built. Below 29th, and east of Slocan, much of the original subdivision was as one and a half acre plots where as one real estate promoter's newspaper ad pointed out, they had "ideal country residences with city priviledges" for sale. Other real estate folks subdivided their holdings into standard residential lots; it makes for an erratic street system.

This tour is longer than the others in the book and is in two parts. The first part is primarily east of Earles where heritage homes mix with a wide range of more modern development; the second part is adapted from a tour which originally appeared in *Vancouver Walks* (Steller Press, 2003).

☞ Leave the station in the direction of the bus loop. Cross 29th Avenue to Atlin. Walk north.

29th Avenue was the boundary between the Hastings Townsite - it was annexed by the City of Vancouver in 1911 - and the Municipality of South Vancouver. Atlin Street runs along side of the Renfrew Ravine so that the homes on the east side of the street have rear yards extending into the ravine. Some of the lots here are 275 feet long. Many of the homes along the street date from the 1960s and 70s but at 27th Avenue C.E. Vincent at 4326 Atlin and his neighbour at 4309 Atlin chose the Craftsman style for their homes in 1912.

Farther down Atlin, a striking modern home is a great addition to the street and stands in complete contrast with the delightful rustic Craftsman built in 1928 at 4250 Atlin.

☞ Walk back to 27th, turn east and cross the ravine. Turn south and follow the path to 29th Avenue.

27th Avenue ends at the Renfrew Ravine and becomes a causeway across the ravine and through the forest. The creek at the bottom of this deep

cut is one of the last remaining natural stream courses in the city where the coolness of the forest, coupled with the sound of water is in such contrast to the surrounding city. This natural ravine gives a good impression of the landscape early residents were building in. Follow the trail on the east side of the ravine out to 29th Avenue.

☞ At 29th turn east and walk to Earles. Cross and walk along Wellington to Reid.

On 29th Avenue the City of Vancouver's Heritage Foundation's True Colours Program painted the 1912 Craftsman home at 2919 29th Avenue in its original colours in 2000. Farther down the block 2975 29th Aveune is a little Craftsman end gable cottage, also known as a Pasadena Bungalow, from 1912, which could use a little bit of care.

Across Earles, the streets take off at a sharp angle from 29th Avenue because they were all surveyed perpendicular to Kingsway - the original road in the area. The local landmark 3018 29th Avenue at the intersection sits across the former boundary between the City of Vancouver and the Municipality of South Vancouver; it was home to Frank Rutledge in the 1930s. The Earles Road station of the BCER was close by. Across 29th Avenue there is a lonely little Craftsman cottage at 3021 29th Avenue built in 1930.

At Moss Street there are two interesting variations on the Vancouver Special with very deep roof overhangs, they sit next to one of the first houses on this block built in 1910. In complete contrast are the two modern spec houses, completed in 2004, on the northside of the street between Moss and Picton.

In March the flowering cherries on Wellington put on a spectacular display of brilliant pink. The tree's heavy mis-shapen trunks are because a stronger, faster growing root stock was grafted to the decorative flowering tree and because the root stock grows much faster than the top of the tree the trunks can take on these great twisted proportions.

in 1912 the two houses on the north side of Wellington were the only houses between Manor and Reid. The generous porch of 3211 Wellington

would have afforded the owner unobstructed views to the south over the BCER Interurban line. In the 1920s a small greenhouse operation popped up across the street on the southwest corner of Manor and Wellington; quite a few residents made some income from agriculture in the area before and just after the First World War.

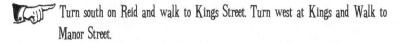 Turn south on Reid and walk to Kings Street. Turn west at Kings and Walk to Manor Street.

Before turning south on Reid look for the big Craftsman home at 4561 Reid, one of the only houses in this area on the City of Vancouver's Heritage Register - it was home to R.M. Dyer a blacksmith for the Canadian Bakery Company and one presumes Mr Dyer provided horseshoes for the delivery horses. There's not much on Reid Street to look at except for a couple of Craftsman homes such as, 4761 Reid which has some nice details down the side of the house, and 4796 Reid at the corner which was updated sometime in the late 1940s, when the porch was incorporated into the living space. And there is the tiny bungalow at 4740 Reid built in the 1930s and home to labourer A. Rogers.

On King Street the tiny house, at 3140 King, probably won't be long for the bulldozer, I'm sure. This little box of a house is so typical of what was built en mass in the early automobile related developments at the end of the 1930s across the United States. The style is Cape Cod and this is about as small as you can get. The house is also a probable example of the "Loxstave" prefabrication system used in Canada by the Wartime Housing Company, the predecessor to the Canadian Mortage and Housing Corporation. Under this system, modest houses could be erected in just one day and in Marpole, south Vancouver, on French Street between 67th and 70th Avenue, the Orchard Park subdivision was built using the system.

The Cape Cod is a most versatile style and can come in many shapes and sizes from the simple box to elaborate multi-gabeled, shingled houses. In the early subdivisions the Cape Cod said "home" to many new home buyers who liked the traditional lines. Even with the postwar housing boom and the advent of the popular Ranch styles the Cape Cod continued to be built in great numbers and some builders were able to combine the best of both worlds and create Cape Cod Ranchers.

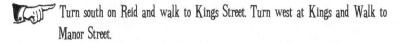 Walk up Manor to Queen Street turn west and walk to Picton. Walk down the lane to Moss Street.

Queen Street crosses what were a series of one and a half acre lots be-fore joining Picton Street. The large featureless house at 4598 Moss, at the lane, dates from 1912 and was home to Fred Switzer a millwright with the Hastings Shingle Manufacturing Company. That company "the largest shingle mill in the world" operated in British Columbia and Wash-ington State and was owned by lumbermen Robert and James McNair. The McNair family had extensive interests in many aspects of the forest in-dustry. A Mr Douglas was his immediate neighbour to the north and at 4558 Moss, carpenter William Smith and his wife occupied the lovely Pyra-mid bungalow with glassed in sun porch.

One early resident on Picton was the intriguing John Francis Bursill, founder of the Collingwood Free Library and Bursill Institute in 1911 (the institute lasted until 1953 as a privately funded body) and was the predecessor to the Collingwood branch of the Vancouver Public Library. He wrote exten-sively for local papers,contributing a regular literary column to the Van-couver World under the pen name "Felix Penne" (fortunate pen), organ-ized art shows, founded a Shakespere Society and the Vagabonds Club "to promote good fellowship and cultivate intellectual vagabondage".

The lanes in the neighbourhood are fun to walk down because they often dead end against different property boundarys or follow the quirky subdi-vision patterns created from the early haphazard land use. Just before King the lane to the west illustrates this quite nicely.

 Walk west on King to Earles and turn north to 29th Avenue. Cross Earles and walk to the SkyTrain station.

At King and Earles the former BCER sub-station, once used to power the Interurban line, has been converted into condominiums in a very success-ful reuse of a building. The adaptation won a City of Vancouver Heritage Award a few years ago.

On Earles amongst the new construction a small group of early homes still hang on close to 29th Avenue. Mr Knox, an engineer, called 4519 Earles (on the west side of the street) home for many years. With its double dormers its very similar to the home of carpenter David Reucassel across the street at 4504 Earles. In Mr Reucassel's yard, which ran up to 29th, Edwin Hickman ran a grocery and butchers, which served customers get-ting off at the Earles Road station (station buildings were nothing much

more than a small shed not much bigger than one of Vancouver's modern bus shelters). Reucassel's neighbours to the south were the Forsbecks, Charles was a millwright and his son worked for Northern Messenger.

Cross Earles at the light and walk to the SkyTrain station on 29th. If you're doing part two of the tour carry on past the station and park, and head for Slocan Street. The tour starts on Gothard Street.

 Part Two

Gothard is a curious street. For the first few years of its existence it had no name until it borrowed the Gothard name from the street immediately to the west (today's Clarendon). Gothard is Ambrose Gothard who owned property in the area and dabbled in real estate.

There was some development on the street in the early years - the most impressive house in the area has to be 4525 Gothard sitting at the top of the ridge overlooking 29th Avenue and angled to take full advantage of the views across the city and Burrard Inlet - but it took until the 1950's to fill in most of the lots. Early residents on the street included John and Matthew Dillabough. John was an electrician in 1910 but by the 1930's is listed as a steamfitter in the directories. Matthew worked downtown at the Crystal Theatre on Hastings between Abbott and Carrall before the First World War. The Dillabbough and Gothard families were related through marriage.

Part of the 1950's development included The True Jesus Church at 4580 Gothard originally constructed in 1959 to replace the simple shingle style Beaconsfield United Church that sat on Slocan. The design is by the prolific church architect R. William Wilding. The former church site is now a parking lot for the current building. It's new congregation reflects the changing nature of the neighbourhood. The block is a mixture of pre-World War One homes, primarily on the west side of the street, 2619 Gothard is one such example, and houses from the 1950's and 60's. 4627 Gothard is a stand out with its large fieldstone chimney.

👉 Turn west on Norquay to Clarendon

Norquay was cut through the block from Slocan in the 1920's. Looking east along the street before dropping down to Clarendon offers a fine view of the 1913 Norquay School. Sir John Norquay a Metis and premier of Manitoba in 1878 is the school's namesake. On school mornings the innovative 'walking school bus' can be seen weaving through the neighbourhood picking up students on its way to the school.

At the bottom of Norquay the streets all meet at odd angles due to the first subdivisions farther east where the streets were surveyed perpendicular to Kingsway; here, where they meet with the regular north south grid it creates irregularities.

👉 Turn north on Clarendon to Brock. Turn west on Brock. Walk to the lane before Nanaimo

Brock is a short street named for Sir Isaac Brock, the defender of Upper Canada in the War of 1812. The houses along the street were largely built in the 1920's. Various house plan companies, notably Sears Roebuck and their Honor Built homes, featured elements taken from an idealized notion of the English village. Many of these homes had steep roof peaks over the entrance and multiple dormers. These house designs were known as "Americanized English" (we'll call them English Revival homes) and were popular with builders and homeowners. A couple of examples on the street stand out such as, 2536 and 2465 Brock. At the end of the block at the lane, 2442 Brock is interesting with its angled front door.

👉 Turn north up the lane to 29th

The dramatic drop to Nanamio is what's left of a ravine and creek that used to feed Trout Lake. On this block of 29th Avenue the 1914 Heal house at 2473 East 29th stands out. The house which has seen better days was built by the printer Stephen Heal who was probably attracted to the area by the reasonable $800 price for lots. According to the building permit Heal spent just under $3000 to construct it. His immediate neighbour to the east, Mr. Williams managed to spend only $500 for his house the year before. The Heal family included, book keeper Freda, James a shipper with Elliot and Teetzl, and Laura a steno with the Kardex Company which manufactured (and still does) the Visible Record System.

On the south side of the block are a few examples of the Craftsman cottage of which 2440 East 29th is a good example.

 Walk to Kamloops. turn north to East 28th Avenue. Turn East and walk to Clinton.

Before turning on Kamloops, the large dip in 29th Avenue is the former stream bed of the creek which ran along Clarendon. Kamloops descends into the former stream course and it can be traced by looking north and following the various dips in the streets. Here on 28th Avenue the mixture of house styles is quite representative of the different periods of building activity. To the west, the first house in the 2400 block was built by a Mr. Holmes at 2481 East 28th in 1911. That same year H. J. Pearce bought three lots in the 2500 block and spent $3500 to construct a one and a half storey concrete bungalow at 2552 East 28th which has been demolished.

At the corner of Kamloops and 28th 2505 East 28th is another example of the English Revival house. While next door the shape of 2511 East 28th and its very deep porch which would suggest there is an elegant Craftsman bungalow hiding in there under the stucco similar to the ones constructed by the California Bungalow Construction Company seen on the Broadway Station tour.

Along the street on the south side, are a couple of houses built in 1967 at 2556 and 2562 East 28th trying hard to remain upright they illustrate the perils of building on top of a stream bed. The houses directly behind them on 29th suffer from the same sinking feeling. Across the street 2545 East 28th is a good example of the English Revival style with its shingles rolled over the eaves to imitate a thatched roof.

The large Craftsman home at 2582 East 28th with its deep porch has undergone a sensitive renovation.

 Cross Penticton

In 1912 Frank Sweetnam, a carpenter built the prominent house at 2614 East 28th for himself. Norman Sweetnam, a printer with the National Box and Carton Company lived there too. In 1926 the Sweetnams sold the house and C. J. Fletcher, executive secretary of the B. C. Medical Asso-

ciation moved in. For a time, Fletcher's next door neighbour was the mining engineer Thomas Bottsrill at 2630 East 28th whose house has the granite piers holding up the porch. Chauffeur William Cuff's house at 2636 East 28th was built to the same plans as Bootsrill's but has been renovated.

Across the street 2637 East 28th built by Master Mariner George Shapland was the first house on the block. In 1913 Shapland took out a building permit for an office and store at the same address though its not clear if it was ever built.

In the 1920's three spec houses in the popular Craftsman style were erected at the end of the block on the south side of the street. 2658 East 28th and its neighbours are typical of the builders "bungalow specials" of the period.

 Return to Penticton turn south to East 29th Avenue.

As development encroached on the natural landscape, existing streams and creeks were usually culverted and buried. The only evidence of their continued existence, other than the occassional sinking house, is the sound of rushing water to be heard at various manhole covers. On the walk up to 29th Avenue take a listen.

At the top of Penticton and 29th the view to the north and the mountains is rather good. It explains the presence of a couple of large homes such as 2623 East 29th which Robert Fisher and his wife Annie built in 1912. Next door at 2621 East 29th, Ala Willis, director of T. B. Cuthbertson Co. Ltd. enjoyed the view from his impressive Craftsman house in 1921. But by 1926 the mining business must have treated Thomas Bottsrill reasonably well because he decided to move up the hill from 28th Avenue and into the house.

Before returning to Slocan and the SkyTrain Station take a look at the very pleasant 1920's stucco cottage tucked behind the hedge at 2593 East 29th

From here it's a short walk back to the SkyTrain Station, or a few blocks south to Kingsway where there's a variety of places to grab a bite to eat and rest the feet. A block west of Slocan on the north side of Kingsway is the Vancouver institution of Wally's Drive-in, the last true drive-in within the city limits and home of the delicious Deluxe Chuck Wagon burger.

9

Joyce Station

The community around the Joyce Station was a thousand strong by 1909 with its own post office, doctor, butcher, plus numerous real estate offices and nurseries. With the advent of SkyTrain in 1985 a new Collingwood of condominium and rental towers began to emerge from the former trackside warehouses, clustered near Vanness.

The original settlers were attracted to the fertile soil of the former lake which once sat between Kingsway and Vanness. The lake is responsible for the odd angled streets in the district because Kingsway, once part of an early military trail to Burrard Inlet, follows the route of earlier native trails that ran parallel to the lake shore. In the 1860's Colonel Moody of the Royal Engineers took a fancy to the unnamed lake and laid claim to it and the surrounding land. As it was one of the first pre emptions in an unsurveyed landscape the boundaries of the claim forced others to work around them. Hence the angle of Kingsway and the old BCER right-of-way.

Exit the station on the west side and walk along Vanness to McHardy. Turn south and walk to Clive.

Vanness runs along the top side of Col. Moody's original claim. The slope of McHardy to the south is the bank of the old lake which was drained in the 1890s to create agricultural land. On Clive, where the flowering cherry trees present a wonderful display in early spring, the houses are a mixture of Vancouver Specials, townhouses, and bungalows from the 50s and 60s. At the far end of the street many of the homes were built facing Vanness instead of Clive in part because of the close proximity of the Rupert Street station. The Burmans (Arthur, Ivy and William), and gardener Tom Forman, were some of the folks who lived opposite the tracks, their backyards extending to Clive. The early station certainly accounts for the grouping of homes from 1910 on the west side of Spencer (for a brief time known as Brittany Street). During the years of the First World War many of these homes were listed as vacant in the directories as men were off in Europe fighting.

Farther down the street are some Craftsman cottages at 4981 and 4995 Spencer, very typical homes in this style, a couple of doors down 5027 Spencer and its neighbour are good examples with the split verge boards on the porch gable. Across the street 4928 Spencer has an interesting gable end where the shingles have been brought around and fill in the entire face. 4950 Spencer has undergone a recent renovation where the stucco layers were removed revealing the original siding underneath. In the 1920s this was one of only two houses on this side of the street and the owners could take full advantage of the large porch which runs down the side of the house.

Turn east on Austrey and walk to McHardy. At McHardy turn south to Euclid and walk east to Cecil Street.

On Austrey a big property owner had six lots on the north side of the street and tucked his house up against the back property line. On the opposite side of the street some of the houses sit on sixty foot wide lots, Mr Rolston who worked for BC Sugar occupied the home at 3256 Austrey. The steep pitched roof makes it look like a farm house, though its height would indicate it has been raised at some point in its life. A couple of doors down, 3276 Austery was the home of Charles Dennis just before the First World War when he worked for Max J. Cameron's clothing store on Cordova as a clerk. Its more recent renovation has created a pleasant Japanese influenced house. Hudsons Bay Company warehouseman Charles Greenhalgh lived across the street at 3269 Austrey in the wonderful tall shingled Craftsman house built in 1911. With its sleeping porch and oriel windows, it is one of the very few buildings on the City of Vancouver's Heritage Register in this area.

At Euclid Avenue and McHardy Street labourer T. Carrari and his wife Emelia bought two lots at the corner for their house and garden in 1910 but by the 1950s the one lot was sold off for the construction of the little

bungalow at 3301 Euclid. The Carrari's house looks like a Craftsman from the front - all of the elements are there, cut out brackets, stone foundation and wide sharp pointed verge boards - but this is an addition to the original house which can be seen by walking a little farther along the street and looking at the side of the house.

The street names in the area often recall some of the original settlers such as James McHardy who bought out here in 1908 but Euclid Avenue is named for Euclid of Alexandria known for his treatise on mathematics, *The Elements*, which was still taught in schools in the 1890s. East of Joyce another mathematician, Archmedes, also gets his own street.

Collingwood Park has a 1950s field house with a coloured granite base. These field houses were once a standard feature of most Vancouver parks. Looking up across the park you can see the slope up to Kingsway, the southern edge of the former lake. At McKinnon and Euclid look at the sidewalk for the street's former name, David, stamped in the concrete in 1948 two years before the street's name was changed. The City of Vancouver used to stamp both name and date on all of its new sidewalks. In South Vancouver there are no dates before 1929 since the old municipality built few sidewalks and it is only after amalgamation with Vancouver in 1929 that the majority of sidewalks were laid.

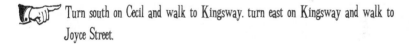 Turn south on Cecil and walk to Kingsway. turn east on Kingsway and walk to Joyce Street.

On Cecil the oddest building must be the 1912 house occupied by painter C. Lutz in 1932 which started off as a simple one-storey dwelling before being jacked up into space for a new bottom storey. Across the street 5350 and 5358 Cecil are pattern book houses from the 1920s featuring the clipped gable or jerkin roof. These homes match the house farther up the street at 5408 Cecil which was home to carpenter J.A.Poole. In the 1920s there were all but five houses on the east side of Cecil while a few more had been built on the western side. The jog in Cecil, something that is repeated in the streets to the west, is because of two seperate surveys meeting and not lining up.

At the top of the hill is Kingsway. In 1913 officials from Vancouver, South Vancouver, Burnaby and New Westminster gathered to celebrate the paving and widening of the new Kingsway - named after the London, England road constructed in 1905 - with a motorcade that began at Vancouver's

city hall on Main Street. That same year the street car line was extended along Kingsway to Joyce Road. Straight across Kingsway is Sir Guy Carleton School. It has the distinction of being the oldest standing school in Vancouver. Opened in 1895 in a storefront on Kingsway near Boundary the school grew quicky and moved to its current site in 1896 and into a one room building which today serves the school's kindergarten students. In 1908 architect W.T. Whiteway designed a new eight room wood-framed building which was complemented by W.H Bowman's red brick school design of 1911.

In 1910 the South Vancouver School Board decided to name local schools after famous "Canadians" and Collingwood School became Sir Guy Carleton after the first Baron Dorchester, Sir Guy Carleton, who arrived in Canada in 1758 and served as governor and commander-in-chief in Québec from 1766 to 1778. He was knighted for his defence of Quebec City in 1775 and later served again as governor of Québec from 1786 to 1796.

> **SkyTrain Notes:**
> On board the train a combination of musical chimes and announcements play to signal stations, route and that the doors are closing.
>
> Three note chimes mean the doors are closing, two notes means a route announcement and one note signals an upcoming station.

During the First World War many former students signed up for duty and even school principal Alexander Martin, who joined the 72nd Regiment of the Seaforth Highlanders of Canada in 1916 leaving his wife Flora at home - he returned after the war. Those that did not return are commemorated at the school with trees planted along the school's front walk.

Next to the school on McKinnon Street was F.C. Engelland's Carleton Sash and Door factory and across from the school on Kingsway between Cecil and McKinnon, the Kingsway Theatre would keep kids entertained with movies on Saturday mornings. A block east of Joyce was the site of the Collingwood Inn, a stop for travellers on the old False Creek/Westminster Road. Much of the business along this section of Kingsway was for the local population and since it was the end of the local streetcar service it made sense to set up shop here.

☞ Cross Joyce, turn north and walk to Church Street. Walk along Church to Stanford Street.

On Joyce the windowless concrete box next to 5455 Joyce - the home to Rev. Beausoleil in the 1930s - is a BC Hydro sub station used to power the trolley bus system, its one of several non-descript structures the com-

pany has around the city. Next door to the reverend's home was the original location of St. Mary's Roman Catholic Church established in 1923 - it might explain the name and location of Church Street. Rev. Beausoleil served St Mary's from its founding until his death in 1940.

On Church Street at the corner, 3303 Church, is a lovely ranch bungalow constructed in 1947, note the use of the always popular coloured stone for decoration along the front. Across the lane the Greuelings made 3311 Church, built in 1910, their home in the 1930s; its a typical builder's pattern book house which we've seen many examples of on the tours in this book. Over the years the house has grown a number of additions on the roof line. Across the street are two big Craftsmans both built about 1912. 3238 is the larger of the two and features some half timbering tucked up in the roof peak and was home to the Rev.R. Matheson in the 1930s. In the former sideyard of the Reverend's home a little late 1940s bungalow has been constructed - whip the vinyl siding off the house and there's an attractive modern house hidden underneath. With its compact design the windows have been brought to the corners for maximum light and maximum wall space inside. The chimney provides the focal point on the facade and note the front door with its port hole design, the one solid clue to the homes age and original design.

The gem on the street has to be the property at 3352/54 Church with its extensive gardens. The main house is an excellent example of the English Revival style with its shingles wrapped around the eaves and the curved castle-like entrance for the front door. Further interest is provided by the leaded windows and their curved tops, a style usually found on Spanish stlye homes of the period. A second house is tucked up against the lane at the back of the property barely visible through the garden.

The rest of Church Street is a mixture of Craftsman homes (3343 Church is a nice example of a modest bungalow), 40s and 50s bungalows and more modern construction. As is the fate of much of the eastside of Vancouver the new homes march through neighbourhoods and soon very little is left of the original development. The view along Stanford and Cherry Streets is typical. Recent tiddles to the zoning to try and generate more interesting homes usually results in more badly proportioned houses gracing the streets.

 Walk north on Stanford to Cherry and walk west to Joyce, turn north at the lane and walk to Archimedes, turn west and walk to Joyce.

Along Cherry Street the homes on the southside face the backyards of the houses across the street which front on Archimedes Street. Near the end of Cherry was George Wharff's greenhouse operation, the largest nursery in South Vancouver - at least that's what his advertising said - where he specialized in tomatoes and chrysanthemums. His house on Archimedes and that of H. Payne next door at 3340 were the only other development on the block in the 1920s and early 30s. At Joyce and Archimedes the view east is of the forest in Burnaby's Central Park. On Joyce there are hints of the old business district of Collingwood on the street. The odd apartment building here and there survive hidden under stucco and aluminum windows such as 5363 Joyce and 5330/32 Joyce. In between these apartment buildings are two cute little Pyramid bungalows at 5342 and 5352 Joyce.

 Turn east at Euclid and walk down Euclid to the playing fields. Cross the fields and walk west along Crowely to Joyce and the station.

On the northwest corner of Euclid and Joyce is the modern complex of St. Mary's Roman Catholic Church with its school, church and seniors housing tower. Along Euclid there is a variation on the Vancouver Special at 3438 Euclid which uses stone as a feature wall while farther up the street there is the truly original creation of 3440 Euclid where the owner has embellished the facade of the house with an amazing array of stones and created a unique arrangement of decoration for the balcony. Neat.

The walk back to the SkyTrain station is through the recent developments of Collingwood Village which has brought a new vitality to the neighbour-hood. Its a bit of a contrast to the 1909 description of the Collingwood East area that noted " the country generally is undulating, the soil rich and scenery thoroughly British Columbian...the population is of about a thousand of the most prosperous and enterprising people to be found in the province."

Refresh yourself with bubble tea at the corner of Joyce and Vanness be-fore heading off on SkyTrain. Bubble tea, also known as pearl tea or milk tea, is a Tiawanese concoction of teas, fruit juices mixed with ice and served with giant tapioca, hence the large diameter straws you get with the drink. Perfect on a hot day.

Burnaby

What to see along the line:

At Patterson, the forest of Central Park is on the right.

After Metrotown the view to the right is of the 1960s apartment district and then out over Richmond. The smoke in the distance is a cement plant. To the left, Burnaby and Deer lakes along with great views of the mountains.

To the left after Metrotown look for Burnaby Mountain and the SFU campus.

After Royal Oak look left for the humps on the roof of the plastics factory. (see page 94)

The forest of Byrne Creek park comes into view just before Edmonds station.

10

Patterson Station

A t the edge of Central Park in Burnaby, Patterson Station, named for the pioneer settler Dugald Patterson who purchased property here in 1894 two years after the municipality of Burnaby was incorporated, preserves one of the original station names along the old BCER route. The area around the station has undergone considerable change since the construction of the SkyTrain line in 1985. Once a neighbourhood largely made up of single family homes, the creation of the Metrotown Centre has meant a complete transformation into a condominium district. The few homes that do remain won't be long for this world. In Patterson's time agriculture was the primary activity out here with small five and two and a half acre plots producing fruits, berries, honey and a lot of chickens.

Leave the station at the exit closest to the park. Walk through the park to the corner of Patterson and Kingsway.

Patterson Station lies on the western edge of Central Park. Set aside by Col. Moody of the Royal Engineers in 1860 as a military reserve - similar reserves were created at what is now Stanley and Jericho Parks in the future City of Vancouver - the land was turned into a park by the provincial government in 1891. Some speculate that David Oppenheimer who was active with the New Westminster Vancouver Tramway Company, whose Interurban line crossed the northeast corner of the park, was instrumental in naming the park after his hometown greenspace which had opened to great acclaim in 1878, however its just as likely that because the park was the mid-point between the communities of Vancouver and New Westminster that its name became Central Park. In 1992, in celebration of Burnaby's one hundreth birthday, the province deeded the park to the city.

Walking through the park towards Kingsway the crisp lawns of the South Burnaby Lawn Bowling Club are nearby; parts of the facility were originally constructed using timber harvested from the area's forest. In the centre of this portion of Central Park local pioneers erected the Agricul-

tural Association and Farmer's Institute Hall which served the comunity until its demolition in 1921. At the northeast corner of the park, at Kingsway, the lawn and open space gives way to the small formal landscape of Jubilee Grove created in 1935 to commemorate the Jubilee of King George V. The "entrance" from Kingsway is through the Jubilee Arch which is actually a small part of Vancouver architecture relocated to Burnaby. The Haddington Island stone arch once stood on Hastings Street as part of the old Vancouver Club constructed in 1893. When the building was demolished in the 1930s (the club had long ago moved to new and grander premises) the stone from the arch was sold to Burnaby where it was re-erected at this location in 1939.

From the park you can look across Kingsway to the Kingsway Four Square Church with its very modern post and beam architecture from the 1960s - note the coloured stone out front. The church shares many of its design elements with the Collingwood library at Rupert and Kingsway in Vancouver and is reminescient of California suburban architecture of the same period.

☞ Cross Kingsway at the pedestrian lights and continue down Patterson.

Patterson drops down from Kingsway into the same valley which contained the shallow lake from the previous tour. The rapid redevelopment inspired by Metrotown gives way on the north side of Kingsway to an irregular pattern of subdivision where many large chunks of undeveloped property remain - this part of Burnaby was surveyed by the firm of E. B. Hermon in 1899 into two and a half acre plots - such as the chunk between 5511 and 5549 Patterson which is part of the Inman Green parksite. 5511 is a Craftsman home set far back from the street into its own large lot while 5449 Patterson is a good example of the English Revival home.

☞ Turn West on Bond Street and walk to Inman Avenue, cross Inman and walk to Jersey.

At the northwest corner of Bond and Inman the marvelous Craftsman home occupying the large lot was once the home to Mr Sanderson from the accounting department of the Hastings Mill (The Hastings Mill on Burrard Inlet was the first permanent non-native settlement on the south shore of Burrrard Inlet and is, in many ways, the birthplace of the City of Vancouver.) In 1919 Mr Sanderson served as Reeve of Burnaby. If you are

walking by the Sanderson house in Spring or Summer take time to admire the carefully tended garden. Across Inman two houses sit in the trees on a couple of other large lots. 5484 is Thurston from the 20s and 5516 is a nice Craftsman house. Inman Street is named for Capt. James Inman who owned a chuck of property out here before subdividing it in 1902 for lots to be sold. A little farther along Bond Street at

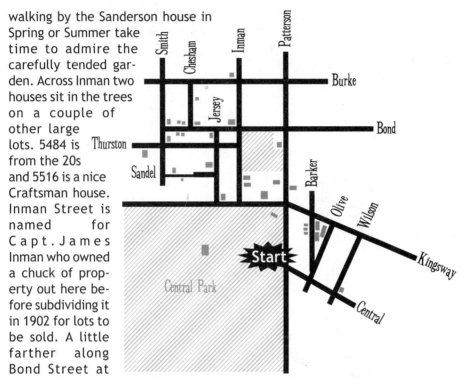

the southwest corner of Jersey is a pleasant California inspired Craftsman with some rather nice porch details.

Turn south on Jersey and walk to Sandell, turn west on Sandell until the lane before Smith Street.

At the northwest corner of Jersey and Sandell, 5575 Jersey, is a fabulous house which is almost lost from view because of the overgrowth of vegetation around it. In the 1920s poultry dealer Walter Lamb made this his residence. Also on the street at the same time as Lamb was Norman Glazier a sign writer for the David Wall Sign Company - it later went into the neon business and was involved in a number of court actions brought by the local patent license holder Neon Products - and florist Albert Hooper who had a green house operation nearby.

The extent of Walter Lamb's property can be seen as you walk along Sandell Road. The road is named for the Sandell family which once ownered a big chunk of property here. The Sandells, Nils, a fisherman; his wife

Clara; daughters Amy, a stenographer for Pacific Mills, and Esther an operator for the phone company; and sons Alex, a labourer and Arthur a moulder all lived in a house on Smith Street. Nils, it seems, was a Swede who jumped ship in 1887, eventually settling in Surrey. Fearing discovery, he changed his name from Anderson to Sandell, married, and moved to Burnaby in 1901.

The eastern portion of Sandell Road is built to modern road standards while the western portion beyond the dividers to Smith Avenue is quite narrow having been developed much earlier. On the street there is a tiny house on the south side at 3868 Sandell which contrasts with the homes opposite while at the end of the block, at the lane, there is a lovely Craftsman cottage that is quite intact.

 Walk north along the lane to Thurston, turn west and walk down Thurston crossing Smith. Return along Thurston to Smith and turn north to Bond Street.

Across Smith is 3762 Thurston the former home of John and Sarah Thurston known as *Altese*. John worked as a manager for the Leckie Shoe Company in Vancouver until 1933 when he left the company to start his own shoe company. Apart from the shoe company in the old coach house on the property the family also raised prize winning chickens. The house has undergone an extensive restoration as part of a larger housing development on the property and is now a protected heritage resource for the city. A couple of doors away from Thurston's the Leckie Company's elevator operator W. Perks resided, It's not known if they rode the streetcar into Vancouver together in the mornings. Thurston Street was renamed in Thurston's honour, it had previously been known as Maxwell after Maxwell Smith an early pioneer who among other things was a founder of the Agricultural Institute in Central Park, school trustee, and Liberal candidate in the provincial election of 1924. Smith Avenue still commemorates this important citizen.

Detour: Walk up to Kingsway on Jersey to see St John the Divine the oldest church in Burnaby. A group of area residents gathered in 1899 to plan for the church which was constructed soon after on a piece of land purchased for one hundred dollars. J.W. Weart who managed to find a way to complete Christ Church in Vancouver also had a hand in the construction of St John by forming the St John Divine Church Building Company Limited. However the handsome new church burned in 1904 and the congregation started again completing the present building in 1905 to the designs of architect Joseph Bowman. In 1998 the congregation moved to renovated premises on Smith Avenue and the building was rented out to the Orthodox Ethiopian Church of Greater Vancouver. In late 2004 the church underwent extensive renovations and restoration, including the removal of the stucco which had been hiding the shiplap siding since the 1950s. Today, St John's looks picture perfect.

On your return to Smith Avenue the wonderful home of Cornelius Newhoven at 5488 Smith comes into view on the northeast corner. Take note of the fabulous short columns on the front porch. Cornelius Newhoven was the manager of Empire Transfer and Storage which he operated out of his home but is also listed in the directories as a rancher. A little farther up the street at the northeast corner of Bond and Smith is a lovely, intact, house from the 1940s, note the windows. Unfortunately a rather nice English Revival home on the west side of the street has been demolished and its large property subdivided.

☞ Turn east on Bond Street to Chesham. Turn north on Chesham to Burke Street.

On Bond Street the houses are obviously from a more modern period and we see the large scale split-level style popular in the 1970s and 80s on the south side of the street while there's the more recent stucco clad homes opposite. In the 1920s the Farrington brothers Thomas and Richard, lived on the block and maintained their poultry business over on Chesham. 5384 Chesham is an interesting Craftsman home which has had a few additions over the years and sits in contrast to the modern split-levels and duplexes on the rest of the street. The only other survivor on the street is the heavily modified house at 5250 Chesham. The tall shape of the house reveals the early age of the house as do the look of the chimney bricks; look for the surviving original stained glass window on the north side of the house.

☞ Turn east on Burke Street and walk to Patterson. Turn south on Patterson and walk to Kingsway.

The majority of the houses on Burke look to be built in the 1950s and 60s. One of the few remaining houses from the 1920s, an unaltered Craftsman bungalow next to 3920 Burke proved to be bulldozer bait and has been erased from the landscape. A little farther on the street at the corner of Patterson and Burke, 4063 Burke is a fine example of a 1960s split-foyer bungalow. Its brick facade and overall style is reminiscent of homes from Eastern Canada.

The walk back to Kingsway along Patterson reveals a wide array of modern construction mixed in with a few older homes. Near Kingsway you can get a better look from this direction at the Craftsman house at 5337 Patterson, tucked into the trees, with its stone porch piers.

☞ Cross Kingsway at the crosswalk and pedestrian lights. Turn east and walk up Barker and Olive Avenue to the SkyTrain station.

The west side of Barker retains a few homes which haven't met with the wrecker's ball yet and gives you a good idea of what the pre-Metrotown area might have looked like. On the opposite side of the street the very large apartment complexes take up much of the block. It replaced a gospel hall and the early homes including that of William Barker at the corner of Kingsway and Barker. Mr Barker worked at Woodwards down-town on Hastings Street.

The Metrotown area has undergone tremendous change as it has evolved into the busy condominium and apartment district it is today. Refresh-ments are on hand at the shopping complex nearby. It's one station along the line or you can walk. If you choose to walk to the Metrotown Malls take a look at the Wilson house at the corner of Wilson and Central Boul-evard. This was the second home of William Wilson and was constructed in 1913 after the property was subdivided; Wilson Road was laid out to gain access for the new lots. In 1996 the house was moved to its current loctation to facilitate the construction of Central Boulevard and it was incorporated into the co-op housing development that now surrounds it.

11

Metrotown Station

T he transformation of Burnaby's Metrotown area was set in place when the decision was made to construct a regional towncentre here in the 1970s. This development has swept away the old Kingsway of burger stands, auto courts, chicken farms, and industry.

The focus of the area today is the three shopping malls which make up the largest shopping complex in British Columbia and occupy almost 58 acres of land; that's three million square feet of retail space and another two million of office space. Much of this development sits on the site once occupied by the old Ford Assembly plant, which started turning out automobiles in the 1938, and the elegant 1940s Kelly Douglas warehouse known for its long ornamental front lawn. Large scale retail first showed up with the construction of the Sears store and catalogue warehouse in 1954 on the site of the old Kingsway East School.

☞ Leave the station and walk across the foot bridge to the malls. Follow the crowd and turn right to find the entrance of the Metropolis mall. Head inside.

The Crystal Palace built for the Great Exhibition of 1851 in London, England designed by Joseph Paxton, is in many ways the forerunner of the modern enclosed shopping mall we know today. That huge glass and steel structure was created to contain space, shelter spectators and display the wealth and products of an empire. Its influence showed up in Ebenezer Howard's influential *Garden Cities of Tomorrow,* as he envisioned glass enclosed shopping arcades to be the heart of his new suburbs - something not lost on twentieth-century developers.

But it was the ideas of Florida resident, John Gorrie, to refrigerate air and supply it to customers - the basis of the air conditioning industy today - which has had the greatest impact on the development of the shopping mall. From the first experiments in 1844 Gorrie's idea, had by 1902, been developed to the point by Willis Carrier that his company was able to supply "manmade weather" to customers. The new system was

unveiled to the public at the St Louis Fair in 1904 and one year later the term "air conditioning" was coined. And from there "manmade weather" was all the rage. Medical schools kept the cadavers cool and theatre patrons sat in comfort and in 1924 Hudsons department store in Detroit installed Carrier's system to prevent fainting during the sales in its bargain basement.

The advent of air conditioning and the ability to circulate and cool the air, along with improved lighting technology, allowed department stores to expand their floor area and yet keep their customers comfortable. Soon there were no limits to what could be done and by 1938 the *Department Store Economist* magazine was excited by the prospects of the windowless department store: "in many ways the elimination of windows adds to the beauty and to the selling efficiency of the store"

By the 1950s air conditioning was seen as essential to the success of a retail operation and by the 1960s it was deemed necessary. Victor Gruen is credited with designing and building the first enclosed, or "introverted", shopping mall, the Southdale Shopping Centre near Minneapolis. Before Southdale, shopping centres were "extroverted" where stores faced the parking lot. Gruen envisioned the European street and market square as models for his design but protected from the elements. He saw his shopping centres as the new town centre with all of the functions and services normally associated with the city contained under one roof. Southdale had a block-long three-storey "Garden Court" where "everywhere shoppers looked they encountered eye-catching features: brightly plumed song birds, art objects, decorative lighting, fountains, tropical plants, trees and flowers." The original press release continues: "The physical environment was thought to quicken the human impulse to mingle, and create an atmosphere of leisure, excitement and intimacy similar to a European market square." From Southdale the future of retail was set and the basic model has been followed ever since.

There are two basic mall types, the Dumbell and Cluster. With the Dumbell retail stores are arranged in a linear path between two anchor stores while the Cluster model has stores arranged into groups with circulation occurring at a number of intersections. Variations of both models are used at Metrotown.

The Metrotown Complex consists of Metropolis, Metrotown Centre and Station Square. Metropolis opened as the Eaton's Centre in 1989 while Metrotown Centre opened in 1986 within the shell of the old Sears cata-

logue warehouse. Station Square follows an older model and is oriented to the parking lot and open to the elements. Since 2002 Metropolis and Metrotown Centre have been under the same ownership.

Walking into the mall you'll notice that insurance agencies, banks and information kiosks are usually the first things you encounter. There's nothing really interesting at the entrances because studies have shown that the walking speed of shoppers doesn't decrease until they get farther into the space and a bank is not something you visit on impulse.

Side bar: Kingsway was the Pacific Coast Highway and the automobile connection to the United States. In the 1930s 26 out of 39 auto court/camp listings were on Kingsway.

Once inside the mall, after the first turn, visually there is little in the way of clues to where you have come from. This is important to shopping where the visual disorientation, sensory overload, or excitement, and a "relentless interior perspective mimicking infinity" draws you deeper into the mall. (Hand rails are always transparent so that the view through the mall and between floors is not disrupted.) And that first turn is almost always a right-hand turn because, again, studies have shown that upon entering a space people will "invariably and reflexively" turn to the right.

Auto tourism was so popular that Burnaby seeing itself as a "tourist mecca" opened an auto camp in Central Park in 1922.

The main corridor is about the length of three city blocks which is about as far as shopping interest can be maintained. So the placement of seating areas and food courts are often strategically placed at the point the shopper starts to lose steam.

The mall became very successfull at absorbing the ambience of the street, as planners began to tidy up the city and pass bylaws limiting advertising. Inside, the signage is more varied and detailed, and shopfronts are individualized to a greater degree than would be permitted in the civic realm. It's interesting to note that the backlash against neon on city streets wasn't reflected in the mall, as neon is a perfect choice for signs as it can be seen from a great distance and provides intense colour.

The lighting in the mall is very important. Skylights will have lights next to them which will come on as the natural light fades, so that there are no clues to the patrons that it's time to go home. And the overall lighting is set so as not to glare on the store windows and obscure the merchandise.

Malls also have to keep up with fashion and are constantly reinventing themselves. New services and concepts must be implemented to keep the patrons interested. The main principle behind the introverted mall has been to provide all of the stimulai inside and to ignore the outside world but new ideas in mall design are evident in the new food court at Metrotown where, for the first time, there are windows to the outside world and the colours are light and bright unlike the previous food court. As well, the exterior which was a blank box has become colourful Vegas-like "billboard" with the major renovation and addition of the Playdium games and entertainment complex on the Kingsway side of the mall.

When Victor Gruen unveiled Southdale Mall he envisioned it at the heart of a 463 acre development complete with apartment buildings, schools, housing and parks, it was never intended to stand alone in a sea of parking. Unfortunately his vision was never fulfilled but here at Metrotown the careful and visionary planning of this area has come close to the original idea Gruen had for his mall and has created a dynamic, vibrant centre of apartment buildings, schools, housing and parks.

12

Royal Oak Station

The first thing you see when you step out of the Royal Oak station is the M&B Grocery at Royal Oak and the right-of-way. Built in the early 1920s it served folks arriving at the Royal Oak stop on the BCER and is typical of the grocery stores of the day. The proprietor would live behind or above the store and work fairly long hours. At the time of its opening the store was serving a small community of residents originally drawn to the area for its agricultural prospects. Small holdings for berry farming were sold as early as 1894 but it wasn't until just before the First World War that there was enough of a population for the directories of the period to take notice and give Royal Oak its own listing - until the 1920s the directories listed South Burnaby residents according to which BCER station they lived closest to.

☞ Leave the station and walk to Royal Oak. Turn north and walk up Royal Oak to Imperial Street and turn east on Imperial.

Royal Oak takes its name from the stagecoach inn of the same name on Kingsway, it was one of four inns on the route to Vancouver along the old Westminster Road from New Westminster. The Royal Oak inn lasted until 1971 when it was pulled down for a supermarket parking lot. The surrounding area to the north of the SkyTrain line is a pretty drab industrial area without much visual relief though at one time it was a neighbourhood of homes and gardens. However, in 1946 the homeowners found themselves in the midst of a district rezoned for industrial purposes. A few houses hang on amongst the breeze block and concrete like the trio of fine homes at the southeast corner of Royal Oak and Imperial. All three display some fine details like the curved dormers and front entrances; note also the leaded glass windows and interesting window boxes.

Across the street the anonymous city-owned building at 6857 Royal Oak is the temporary home for Tram 1223 which ran on the rails in Burnaby for over sixty years. At the end of rail service in the 1950s #1223 was donated to Burnaby and placed on public display at Kingsway and Edmonds, with

time and the elements taking their toll it was moved to the Burnaby Village Museum for safe keeping. By 1999 it was in rough shape and a volunteer effort was organized to restore #1223, a product of the St Louis Car Company. After its top to bottom restoration it will again rejoin the museum's collection.

☞ Turn east on Imperial and walk to Antrim. turn south and walk to Dorset.

This section of Imperial is a street of auto body and glass shops, garages and other small industrial uses where the odd house still hangs on. Walking through the industry it's a pleasant surprise to come across the Pasedena Bungalow at 5507 Dorset with its interesting side entry to the porch. It is one of a few remaining homes on Dorset though at the other end of the block, 5578 Dorset is a well looked after bungalow in the same style while its neighbour two doors to the west is a good example of a Pyramid bungalow.

☞ Walk along Dorset. Cross MacPherson Avenue and walk to Shirley and turn south.

On the southeast corner of MacPherson and Dorset is the Canadian Ramgarhia Society a temple, or Gurdwara, for the Ramgarhia caste of Sikhs, traditionally artisans such as masons, blacksmiths and carpenters (the word caste, by the way, is a Portuguese one meaning 'group'). Sikhs outside of India are concentrated in just three countries worldwide; Canada, the US and Britain.

The temple is surrounded by industry though a Gambrel roofed house at the corner of Sellers and Dorset manages to hang on. At the far end of Shirley Street Thunderbird Plastics, which manufactures milk crates and other items, is housed in an quirky building. Take a look inside when one of the factory doors is open and you'll see how the roof is held up by a series of what look like open concrete umbrellas - sort of a down-market version of Frank Lloyd Wright's design for the Johnson Wax Company in Racine Wisconsin. The effect is best seen from the SkyTrain where the building's tar and gravel roof looks like a collection of giant sand piles.

☞ Cross over the tracks under the SkyTrain guideway. turn west to MacPherson and turn south to Rumble. Walk west on Rumble to Royal Oak.

There is not a lot to look at on the stretch of MacPherson to Rumble except (at the time of writing) a few abandoned industrial sites. But the whole area is slated for redevelopment into a condominium district of townhomes under the city's 1999 Royal Oak Community Plan.

On the west side of the street the buildings and grounds of Burnaby South Secondary dominate the landscape. The school opened on this site in early 1993 after its move from its original site which the school had occupied on Kingsway since the 1920s; it incorporates the secondary school, the BC Provincial School for The Deaf and the Michael J. Fox Theatre (the actor attended the school in the 1980s). Burnaby South is one of six high schools in the city. An interesting side note is that the Burnaby school district does not name its schools after personalities.

The homes on the south side of Rumble enjoy magnificient views out over the Strait of Georgia, the Gulf Islands and Vancouver Island. In the 1870s Jerry Rogers, the namesake of Vancouver's Jericho beach and the man who logged off most of Point Grey, held a timber lease for a good chunk of the south slope where spars for sailing ships were cut. The area was once known as Alta Vista or "high view" and the name can still be seen on a number of businesses nearby.

Walk up Royal Oak to Watling

At Royal Oak and Watling the current All Saints Anglican Church was constructed in 1958 but the congregation has existed since 1912. Originally it was a mission within the parish boundaries of St John's Anglican at Central Park (see pg. 86) but it became a separate parish in 1913 known as All Saints Alta Vista. By the time the new church buildings were constructed in the 1950s the name had changed to All Saints South Burnaby.

Across the street from the church the large heavily treed property illustrates how much of this area would have looked during the early years of settlement.

☞ Turn west on Watling and walk to Nelson. At Nelson turn north and walk to Victory.

On the southern slope many of the original homes built during Burnaby's boom period in the 1950s and 60s are now falling, or have fallen, to the bulldozer to be replaced by newer and larger homes. 5131 Watling is typical of much of the original development here, as are the big duplexes from the 1970s seen along much of the street. These homes feature soaring double height living rooms that offer lots of natural light with their extra windows across the facade. Builders in Burnaby seem to have pioneered this style of large duplex which share some similarities to the Vancouver Special. 4925 Watling, at the corner of Nelson and Watling, is a good example showing the double height living room.

On Nelson, on the west side of the street, Grace Lutheran is a pleasant example of a modern church. As you pass by note the steep gables of 7225 Nelson. Nelson Avenue and Victory Street are named in honour of the famous admiral and his naval victory at Trafalgar.

☞ Turn east on Victory and walk to Dunblane. From Dunblane continue along Victory to Royal Oak. Turn North to the SkyTrain station.

On Victory the Craftsman house at 4936 Victory exhibits the clipped gables typical of the style but the house has lost its front steps.

At the northwest corner of Victory and Dunblane look down. On the street there is a cast iron cover marked Glenfield, Kilmarnock (Brown's Patent) which hides access to a water valve. It was made by the 152 year old Scottish firm of Glenfield and Kennedy, valve manufacturers, who exported their products world wide. The Municipality of Oak Bay on Vancouver Island had the company make many of their manhole covers which were then shipped across the oceans relatively cheaply because they were used as ballast. When this sidewalk was laid the crews also stamped the street name and date into the concrete something you don't see very often outside of Vancouver.

At Marlbough, a short detour north takes you to Barbell St where the layout of the cul-de-sac is in the shape of a barbell weight. The homes here are gradually being replaced with newer construction but you can still see some of the 1960s Ranchers. This style had its origins in Califor-

nia, as much of our residential architecture seems to have done, in the 1930s. The first Rancher was supposedly built by a gentleman of the name of Cliff May in San Diego in 1932. This simple home laid out on one floor became the dominant house style of the 1950s and 60s in subdivisions across North America. Variations do occur, and the big one was the split level Rancher where the bedrooms are raised above the garage with the living and dining rooms, and kitchen on the lower level. With the Rancher, differences in style were expressed through the odd bit of decoration applied to the front of the house, such as some dark boards in the gable to say Tudor, some brick work for Spanish and scalloped edges to the verge boards in the gable to signify a Swiss chalet. The 1960s was also the era of the "Gold Medallion All-Electric Home" with prospective homeowners urged to "live better electricly" in co-ordinated advertising and marketing programs between home builders and the power companies across North America.

> **Skytrain Notes:**
> The trains are powered by linear induction motors which have no moving parts. The motors get the trains moving with an electromagnetic force. Electrical power is delivered by power rails located at the side of the tracks.

At the intersection of Victory Street and Royal Oak, 5794 Victory, with its sleeping porch on the upper floor, was the 1913 home of BC Electric Railway Company clerk E. Harrison. The house is a typical builder's pattern book house similar to ones already seen on the Broadway Station tour. Across the street from the Harrison house is the Royal Oak Community Church built in 1936 as the Royal Oak Alta Vista Baptist Church, while the striking addition along the Royal Oak side of the property was completed in the 1950s. The church, still affiliated with the Baptist Union of Western Canada, is also home to the Deaf Community Christian Church which offers services to the deaf community in ASL (American sign language).

On the walk up Royal Oak to the station there are several early houses still remaining on both sides of the street. Some of the properties on the west side still have a rural air about them as does the tiny little house on the other side of the street at 7042 Royal Oak.

Rest your feet at the bottom of the station, sit and people watch while sipping cold drinks from the M&B Grocery.

13

Edmonds Station

S kyTrain has had a profound effect on the neighbourhoods it has passed through especially where the stations were built. It's not uncommon to see density increase with the arrival of transit but, apart from Metrotown Centre, the biggest change along the line has to be Edmonds. Here in the semi rural corner of Burnaby the landscape has been transformed by the condominium towers to the south of the station and the new townhouse construction stretching all the way up to Kingsway. Even the 1960s era Middlegate Mall on Kingsway has been transformed and rebuilt as a major residential and retail complex.

At the end of the nineteenth century when planning for the New Westminster Vancouver Interurban railway got underway it was decided to locate the powerhouse at what is today Beresford Street between Mission and Griffiths Avenues. With its boiler room, engine room, machine shop and car barn it was an impressive structure costing almost $20,000. Close by a boarding house was built to accommodate the men who needed to live nearby to ensure the smooth operation of the system. The powerhouse became the centre of an emerging community, it was one of three stops on the early line and the site of the meeting where it was decided to incorporate Burnaby in 1892. Until the 1950s Burnaby city hall was located nearby at Edmonds and Kingsway.

In 1912, H.R.H. the Duke of Connaught, Governor-General of Canada, aboard the special "Connaught" car of the BCER stopped for a municipal ceremony at the Interurban Station on Kingsway at Edmonds. The community had raised a ceremonial arch and according to the "British Columbian Daily", the Duke of Connaught arrived at 11:20am and was greeted by about 500 school children, officials, and spectators. Children carried flags, banners, and maple leafs.

In amongst the vast array of new development a few heritage buildings do remain including the church at 7135 Walker near Kingsway which was originally built in 1912 as the Edmonds Baptist Church and in 1993 became the home of the Southside Community Church under the auspices of the Baptist Union of Western Canada. Southside is a multi-congregational church with congregations throughout the Lower Mainland.

There a few houses in the 7200 block of 17th Avenue worth a look, and of course the Patterson House at 7106 18th Avenue. Built by Dugald Patterson in 1911 after the family moved from the Central Park area, the simple Craftsman house was moved from Edmonds Street to its current location beside Byrne Creek Ravine Park in the 1950s, fitting in a way since Patterson was an early advocate for the preservation of local ravines for parks.

Today the City of Burnaby takes the preservation of its remaining open watercourses seriously. In 1973, the city adopted an Open Watercourse policy to ensure that streams were not enclosed during development. They have passed a Watercourse Bylaw which prohibits noxious substances from being dumped in the streams, provides sediment and erosion control requirements, and stormwater management plans. In addition, Burnaby has also mapped and named all sixty watercourses that continue to run through the city. The Edmonds neighbourhood is lucky to have the Byrne Creek Ravine Park.

Leave the station and turn left, walk through the parking lot to the path alongside the SkyTrain guideway. Walk up the path and take the first left turn and follow the paved trail.

In much of the Lower Mainland creeks and ravines were seen as inconveniences to development and ended up being filled in, culverted and generally erased from the landscape. The Byrne Creek Ravine's eighty-seven acres was set aside in the 1960s as parkland and has been maintained as an undeveloped natural park. It is named after Peter Byrne a local land owner, and forner mayor, who once owned a good chunk of the ravine.

Soon after entering the trees the ground to the right of the trail drops away to reveal the ravine and creek as it tumbles out of a culvert and through a small fish ladder installed in the 1990s. The right fork of the paved path past the information board takes you along the edge of the park next to the condominium development built on the site of the old Dominion Glass plant which closed in 1985. This high-rise neighbourhood features extensive gardens as part of its overall plan. There are a number of opportunities to follow more informal trails into the forest and get some striking views of the ravine. Even on hot summer days the forest remains a cool sancturary from the heat. With the city's network of urban trails it's possible to reach the Fraser River from here.

The Byrne Creek watershed encompasses the South Slope area from Sussex to Tenth Avenue and from Kingsway to the Fraser River. The creek

originates above Kingsway near Edmonds emerging east of the SkyTrain Station before passing under Griffiths and the old BCER right-of-way to follow the deep ravine to Marine Drive and Byrne Road. The creek then enters an artificial spawning and rearing habitat created in the mid-1990s before flowing through a dyked channel to the Fraser River. It is joined on its route to the Fraser by Powerhouse Creek, flowing through the park of the same name, John Matthews Creek, Frogger Creek and Gray Creek.

The Bryne Creek Streamkeepers Society is a group of volunteers dedicated to the stewardship of the creek, keeping it clean, monitoring the fish and other life in the ravine. They are one of eleven such groups in Burnaby. Formed in 1999, the Streamkeepers have worked to promote and educate citizens about the value of the creek and its unique habitat. Among other activities they help organise salmon fry release programs with school students and community groups to restock the creek. The park is home to coho and chum salmon, cutthroat trout, rainbow trout and an abundant bird population.

The group got its start after a toxic substance was dumped into a storm drain in 1998 which then entered the creek killing off thousands of fish. To remind the public that storm drains form an important part of the urban watershed and that everything entering the drains has to go somewhere and thoughtless acts can have devastating consequences the Streamkeepers have, with help of local groups including the Girl Guides, painted yellow fish next to the area's storm drains. As well, the Stream of Dreams project was launched by members of the organization to commemorate the fish killed in the toxic spill. A chain link fence around an empty lot at Edmonds and Kingsway became the home to hundreds of brightly painted fish drawing attention to the unseen stream below the street. When local schools are visited the students hang wooden fish made by the Burnaby Firefighters and painted by the students on the school's fence to "symbolize the new respect for streams"

A walk through the park should renew our own respect for what natural resources survive in our cities and how we can preserve what little remains.

New Westminster

What to see along the line:

On the eastbound train the SkyTrain Control and Maintainence Centre can be see on the left. Within this building are the computers and operators that keep the sysytem running.

The short tunnel just after Edmonds station, heading east, is part of the condominium project next to the station.

Before the 22nd St station, there are great views of the Fraser river, the Alex Fraser bridge, and on clear days, the Gulf Islands to the right.

Between 22nd St and New Westminster the Scott Paper plant is to the right, look for the former Expo 86 pavilions on the mill grounds.

The pink, yellow, and orange stucco condominiums on the riverfront are one developer's idea of bringing a little bit of Venice to the West Coast.

To the left is the Brow of the Hill neighbourhood where many early homes are located.

On the river the public market and floating casino can be seen.

Across the river is the City of Surrey, the fastest growing city in BC. You can just see the top of a new office tower above the tree line.

14

22nd Street

he 22nd Street Station sits near the old BCER station of Elsona on the Highland Park Cutoff in the Connaught Heights neighbourhood of New Westminster. Interestingly enough Connaught Heights didn't officially join the City of New Westminster until the 1960s, prior to that it was administered by the provincial government.

 Walk out of the station and turn right and walk down 7th Avenue to 20th Street.

Leaving the station you can see the truncated remains of the original Highland Park line which cuts an arc across the area on its way to the waterfront and Columbia Street. The line was built in 1912 to allow the trains to avoid the steep grades of 12th Street and when passenger trains stopped running in 1954 the line was used for freight services before being abandoned in the 1990s.

The houses along 7th are typical of the 1930s; given the sporadic early development in the area we'll see a wide range of house styles from the 1930s through to the 1960s on the route.

 Cross 20th Street and follow the signs for the Crosstown Greenway to 7th Avenue.

By crossing 20th Avenue, the former city boundary, we leave Connaught Heights and enter the West End neighbourhood. The first houses were on the north side of 7th, between 20th and Bowler, built about 1912. The homes exhibit typical architectural details of the Craftsman style such as the clipped gable and the decorative post and beam construction that can be seen in the porch. By the 1930s, 1905 7th Avenue was occupied by Mr J.B. Powell who worked downtown on Columbia for the Baxter Motor Company as a book keeper.

A little farther along the street a stone cairn notes that Grimston Park was named in honour of a former parks commissioner in 1956. The view

from the park is out over the Fraser River and to-wards Surrey.

Across the street Adolph Nelson, an early resi-dent on the block in the 1920s, had a house (1823 7th) which drew on the ideas of a style known variously as Tudor Revival, English, Cot-tage, Cotswold, and on and on. We've called it English Revival. The style was found in Shaughnessy and other well-to-do neighbour-hoods in North America where large, instant, "olde world" homes appealed to those want-ing a sense of permanence and links to the past. These styles, simplified for smaller suburban lots, were popularized in numer-ous plan books published in the 1920s and 30s such as *British Columbia Homes*, a collection of designs by local architects, and *Suggestions for Your Home* by Arthur Preusch an architect in St Paul, Minnesota who's plan book was published in Winnipeg as well as St Louis. (Apart from architecture Arthur Preusch and his wife were instrumental in setting up the St Paul Figure Skating Club which first met in their living room in 1935. Arthur and his wife went on to become the mid-western ice dance champions of 1936. His publisher the Louis F. Dow Company was also a noted publisher of pin up pictures.)

In the 1940s George Tomlin, a clerk at Gilley Brothers "coal and crushed rock, sand and gravel, tugs and scows for hire" moved in to 1823 7th Avenue.

In contrast to the English Revival, the Streamline style of the 1930s and 40s was all about being modern and sleek. Much of the style's ascetic was derived from the technology of the day such as airplanes and ocean lin-ers. 1807 7th, a lovely house, shows a hint of the Streamline with its front door with the porthole and leaded glass inserts.

Walk down 18th Street to Nanaimo, turn left and walk to Curnew.

This stretch of Nanaimo Street between 16th and 18th Street was not put through the block until the late 1920s. Development in the neighbourhood tended to be in the blocks close to and either side of 12th Street where the BCER's Interurban line ran into downtown.

The English Revival style can be seen in the details of 1715 Nanaimo with its corner entrance and the large central gable. Here the builder has wrapped the ashphalt shingles around the eaves in an imitation of a thatched roof. On more up-scale homes the roof might be rendered in cedar shingles laid in a complex pattern which came closer to the idea of thatching. Across the street is the simple little house (1708 Nanaimo) belonging to Mr Matthews, who in 1932 was a labourer with the Mohawk Lumber Company on Columbia Street. His neighbour at 1709 was Max Kovish who ran his own general store and confectionary on Eighth Street where the SkyTrain station sits today.

 Turn left and walk up Curnew to 7th Avenue.

Curnew, named for a Captain Curnew, was extended through the block from 7th when Nanaimo was pushed through to 18th. At the foot of Curnew was the large property belonging to lumberman J.B. Wilson. In the centre of the property Wilson built the impressive *Melrose* in 1910. This huge house with its double height columned porch featured a stained glass dome designed by Henry Bloomfield & Sons the well known firm of glass artists. The dome, saved when the house was demolished, is now at the Vancouver Museum.

At 7th and Curnew, turn left and take a look at 1708 7th It has a steep pitched gable and swooping roofline in another variation of the English Revival style. Machinist John Vernon made this his home in the 1940s. Some of the first residents on this block, including carpenters Lancelot Cox, Charles Petrie and Hustler Thomas, moved in to new homes in the 1920s. Two older homes at 1718 and 1720 are listed on the New Westminster Heritage Register.

 Turn around and walk along 7th Avenue to 16th

1621 7th Avenue is a delightful and well preserved example of a style known as Spanish Colonial or Mission Revival. Note the use of the arched

windows for the living room. The style, based very loosely on the California Missions, was made popular throughout North America by the success of the 1915 Panama-California Exposition which helped bring the style to wide attention. The style received a further boost when the Santa Fe and Southern Railways chose it for their railway stations. In British Columbia the style, with its red roof tiles and white walls, showed up in grocery stores, gas stations, apartment blocks and many impressive homes in Shaughnessy. Here the house that mushroom grower Lyle MacDonald called home in the 1940s has ashpalt shingles that wrap around the eaves instead of tile. 1828 8th Avenue is another great example of the style here in the neighbourhood.

Across the street the four houses at 1618, 1614, 1612, and 1608, are examples of the Moderne/Streamline house. 1618, the first of the four built, was home to New Westminster fireman Hartley Dilworth The homes are quite simple with little decoration but with some strong horizontal elements such as the projections over the windows to provide a small amout of sun protection. These houses are versions of a style that took off in the 1930s influenced by trends in industrial design. Beside its modern neighbours 1606 looks back to "olde" England for its design. What is interesting is that all of these styles were popular and being built at the same time in neighbourhoods like this across the country.

At the southeast corner of 16th and 7th is a typical home, generally referred to as a bungalow, from the early 1950s with its coloured granite planter and wall under the bedroom windows. Coloured rock was a favorite design element of the period showing up in both interior and exterior applications. The house takes advantage of its location presenting a single storey to the street while it is two storeys at the rear thanks to the slope on 16th

A few blocks farther on 7th St Aidan's Presbyterian Church of 1910 (1320 7th Avenue) is the original home of the Vagabond Players who formed in 1937. The name came about because of the then lack of a permanent home for their productions.

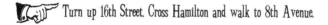 Turn up 16th Street. Cross Hamilton and walk to 8th Avenue.

On the corner is a duplex, which is rare in the area, with its original garage set into the landscaped side yard. Next door is an early house with

its full porch and bell cast, or hipped, roof. In 1911 this was the only house on the street and surrounding blocks. Next door and across the street we can see two late 1960s homes showing how the 1950s house seen back at the corner evolved into what's known as the Split Level Rancher. The basic design could be decorated as the builder's saw fit and the two houses here while basiclly the same plan can look quite different. The basements were largely above ground and a rumpus or rec room took up the space in under the upstairs living room. You can also see the growing influence of the automobile on the design with its open parking (sometimes enclosed) under the house. It was assumed the car was needed for everyday tasks and putting it into a garage separated from the house was just too inconvienient. A little farther up the street at the corner, 1601 Hamilton was the English Revival house of detective Gordon Prowse. The porch of his house has flared walls meant to imitate the stone construction of an earlier period even though it is just plaster on a wood frame.

A short walk up one block to the corner of 8th and 16th reveals the lovely Tudor Craftsman which was home to a Mr Cameron; his job, in the 1920s was as a watchman at the Heaps Engineering Company. In 1912 Cameron's house shared the block with only two other houses. At 827 16th, the Webster house of 1938 is the only designated heritage building in the West End, Connaught Heights area.

 Turn around and walk back to Hamilton, turn right and walk to 19th Street.

This section of Hamilton wasn't put through until the 1920s and the directories for 1926 note "bush here" after 14th Street. When it was pushed through the bush Hendry Street, a short piece of road off of 18th, was incorporated into the new road. The houses along this street show the variety of styles we've already seen on the tour but there are still surprises. BC Distillers engineer Walter Scott made the neat little house at 1604 Hamilton his home in 1946: here the entrance is set off with a stylish stucco entrance and porthole window in contrast to the rest of the house. Next door more industrial materials begin to show up like the steel pole used to support the porch roof. Lord Tweedsmuir School takes up the block between 16th and 18th, it's worth hiking across the school yard to 8th Avenue to check out the striking Art Deco facade of the school and the nifty former grocery store directly across the street.

On the other side of Curnew 1704 Hamilton, an early 50s house, displays a similar, though less detailed, entrance to Mr Scott's down the block.

Continuing along, 1801 Hamilton is a good solid example of the English Revival and typical of the homes of this design the front door is set into a arched porch. Larger English Revival homes found in Shaughnessy for instance, were much truer to their Elizabethan cousins and the front door was often very small in proportion to the rest of the house - though once inside it gave way to a double height hall and foyer. With the suburban home many builders built a standard form and then decorated it in the style that was selling at the moment. In many cases the decoration was pretty minimal and the leaded windows of 1810 Hamilton are the only real indication that this is an English Revival house.

Again, next door is something completely different. Here 1820 is a late 40s house and the design cues are from the Cape Cod - a very versatile house form with its roots in early colonial architecture of New England - and before the advent of the California Rancher it was what builders constructed in great numbers right after the war. Its modest size and well propotioned design fits the neighbourhood and blends in with the area's varied styles.

A more akward fit and an alarming trend in a neighbourhood such as this is the neo-Craftsman. This generic builder's special continues to crop up in well established neighbourhoods around the Lower Mainland, replacing existing homes. Out of scale, out of character - this is a neighbourhood that largely developed after the Craftsman craze had subsided - and just plain inappropriate in most cases, it's disturbing to see the house style make its intrusive way into the West End. Let's hope that the few that have made their appearance don't multiply.

Straight ahead where 19th Street and Hamilton meet, the house at 720 19th is a wonderful late 40s design dominated by the big brick and granite chimney, and porthole window at the entrance. On the next street over 720 Bowler is of a similar design.

 Turn up 19th to the lane, turn left and walk through to Bowler, turn right and walk to 8th Avenue.

At the corner of the lane and Bowler is a little Streamline house hiding under the 1970s era cedar-shingle along the roof line. Homes like these are rare in the lower mainland; few builders tried introducing the style but it did not catch on. With flat roofs and no decoration, besides some

painted steel railings, the homes were too much of a shift for the home buyer accustomed to a more traditional form.

Across the street, facing 8th Avenue, is the former West End Hall home to St Gheorghe Romanian Orthodox church since 1989. Take a look at the stained glass that decorates many of the windows, in particular the gothic arches at the front, and the rather nice Art Nouveau flowers in the windows near the lane. On the other side of 8th you can see the hipped roof and concrete block foundation (it may look like stone but it is concrete cast to look like cut stone) of 1929 8th which gives away its early construction date. Philip Amy, a seaman, was a long time resident here.

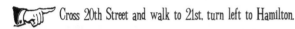 Cross 20th Street and walk to 21st. turn left to Hamilton.

Crossing 20th brings us back into Connaught Heights. Thorne Road became 8th Avenue in 1938 when the Height's street names were harmonized with those of New Westminster. The shopping area on 20th still have a few details of their 1940s construction left in the shop fronts which haven't been swept away by renovations, including the windows which end in a curve, the stucco work and some tiles.

Along 8th Avenue in Connaught Heights, the development continues to show a wide array of styles we've already seen. Visible in the distance is Connaught Heights Pentecostal Assembly. Established in 1934 it was the first Pentecostal church in the city. the congregation moved to this location in 1946 and have renovated that first building a few times since its construction.

At the southwest corner of Hamilton and 21st Avenue, 748 21st Avenue and 2103 Hamilton are tiny little cottages. For something even smaller walk to the end of Hamilton and look at the cute, there is no other word, residence at 2222 Hamilton. From here its a short walk to the edge of the Schara Tzedeck cemetery.

Schara Tzedeck was the first purpose built synagogue in Vancouver when it was constructed in 1911. It expanded into a larger building on the same site in the 1920s but moved with the rest of the Jewish community to Oak Street in the 1940s. The cemetery was established in the 1920s.

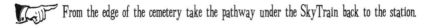 From the edge of the cemetery take the pathway under the SkyTrain back to the station.

New Westminster Station is just one stop along the line heading east.

15

New Westminster Station

The New Westminster station was the end of the original Expo line until 1987 when it was extended to Columbia Street and eventually crossing the Fraser River on a spectacular cable-stayed bridge to terminate at the King George station in Surrey.

New Westminster, the oldest city in Western Canada, was named by Queen Victoria, hence the nickname "Royal City". In 1859 the new city was selected as the capital of the new colony of British Columbia, and again in 1866 when it and the colony of Vancouver Island were almalgamated, though the city eventually lost its capital status to Victoria. The city was an important commercial and transportation centre for the Fraser Valley.

 Leave the station via the 8th Street exit and walk down to Columbia Street

Until comparatively recently Columbia and 8th was a pretty busy inter-section. At the foot of 8th is the small chateau-like CPR station designed by noted Canadian architect Edward Maxwell in 1899 to replace the earlier station destroyed in the fire of 1898. It's worth walking around the building and braving the truck traffic on Front Street to see the rear of the building with its twin turrets. On the opposite corner the former BC Electric Railway depot (the third depot for New Westminster), hidden under a series of nasty looking renovations, was where trains to Vancouver and the Fraser Valley could be boarded. Tracks from Columbia ran through the building to Front Street where both the Canadian Pacific and the Vancouver, Westminster and Yukon (later Great Northern) railways maintained tracks along the waterfront.

Between the two is the pedestrian bridge over the CPR tracks to New Westminster Quay and the public market. You can get a good view of the CPR station by climbing part way up the stairs.

Before heading along Columbia its worth taking a look at the former McLennan, McFeely & Prior Ltd building at 811 Columbia with its Stream-

line Moderne forms designed by McCarter & Nairne in 1939. "Mc & Mc" (used in advertising and on their roof top neon signs) were Robert McLennan and Edward McFeeley, who went into partnership in 1895. Across the street at 801 Columbia is an early Art Deco Safeway store built in the 1930s when the supermarket chain was still oriented to the neighbour-hood and the shopping street.

Columbia Street was once known as the "Golden Mile" and the centre of business and retail for the region. However, with the rise in popularity of the suburban shopping centre the street lost much of its lustre. In an attempt to reinvigorate the street and the downtown, New Westminster has unveiled a number of intiatives including breaks for heritage restora-tion, encouraging residential conversions and new street furniture. The street was destroyed in the fire of 1898.

 Walk on Columbia to 6th Street.

The most obvious building on the skyline is the Westminster Trust build-ing at 713 Columbia. Designed by Gardiner & Mercer in 1912 this steel frame structure was the city's first "skyscraper". Above the storefront entrance to the Westminster Trust and Safe Deposit Company is their logo, a lock and key on a shield sitting below cherub's head. Next door to the Trust Company are two 1899 brick buildings, the Masonic Block at the corner of Lorne and Columbia was reconstructed from the ruins of his earlier building by the noted New Westminster architect G.W. Grant. Both have been renovated and restored in recent years.

Across Lorne, G.W. Grant continued his reconstruction work with a design for a two storey building for T.J. Trapp. In the 1930s the building was occupied by the S.S. Kresge Company. Unfortunately a fire in the late 1980s destroyed the block.

On the other side of the street at the corner of Begbie and Columbia the venerable Windsor Hotel's straightforward Italianate design has been marred by yellow siding which hides the second storey windows and all of the architectural details. Do look for the wonderfully illustrated neon and backlit plastic signs along Begbie and Front Streets denoting Ladies & Escorts, Mens and Licenced Premises. Let's hope they survive for years to come.

The Bank of Nova Scotia across Begbie is Toronto architect, and noted

theatre designer, Murray Brown's Art Deco version of the neo-classical bank building. Along the Begbie Street side of the bank are the symbols of trade and wealth including a sailing schooner, wheat sheaf and a couple of carved panels of loggers. Further details about this building can be found on a plaque, one of many throughout the downtown, mounted on the side of the bank.

The Trapp Block at 668 Columbia, designed by Gardiner & Mercer in 1911, has a terra cotta facade glazed to look like a light granite. The Army & Navy store was here until they moved into the former Eaton's store farther up Columbia in the 1970s. Trapp was a prominent citizen, businessman, and secretary of the New Westminster Southern Railway among other activities. Next door is the former Windjammer Hotel built in 1899. As the plaque displayed out front describes, the hotel has completed a major renovation and has been rechristened as Pier 660.

The Paramount Theatre, beside the hotel, now presents a slightly different show than the movies it played for over seventy years. As a gentleman's club the Paramount at least keeps live entertainment alive. The theatre was built in 1910 as the Edison, a venue for early motion pictures and vaudeville acts, replacing an earlier Edison theatre lower down Columbia. The New Westminster-raised Mandrake the Magician first performed on stage here at an early age, eventually going on to an illustrious career which even spawned a popular comic strip in the 1940s. The marquee was erected in the 1950s when the Famous Players organization changed the name.

At the corner of McKenzie and Colombia the dramatic elevation changes the city is known for can clearly be seen as the road dives towards the river. The treacherous grades were responsible for more than a few street car accidents when conditions made the rails just too slippery. The steep

slope of 6th Street, responsible for one spectacular crash in the early 1900s, prompted the BCER to construct the Highland Park cutoff line which opened to traffic in 1912.

Copp's "the family shoe store" has a prominent position on the corner of McKenzie. The building was constructed in 1904 and Copp's has been here since 1925 when John Percy Copp bought the Popular shoe store which had been in business on the corner since 1910. What's amazing is to step into the store and realize that very little, if anything, has changed since 1910. The six ladders that run on rails alongside the ceiling height shelves, and the huge National cash register are all original. The original motto over the entrance was "The doorway of economy, where good shoes are cheap"

Next to Copp's is the Royal City Cafe, which at one time sported a huge neon sign promoting itself - its a good place to grab fuel for the hills that are to come. Across the street at the corner of 6th and Columbia is the former federal building at 549 Columbia, which was done in a standard Department of Public Works design of the 1950s variations of which could be seen coast to coast. The building today houses the New Westminster police department on two floors while the rest of the building, including a discreet addition to the roof, are condominium units.

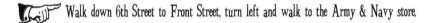 Walk down 6th Street to Front Street, turn left and walk to the Army & Navy store.

Coming down the hill the traffic and noise is a surprise after the relative quite of Columbia. In 1912 three different railways had their track along the street; today freight trains still blast along the waterfront but Front Street is over-shadowed by the extraordinary four block long waterfront parkade constructed by the City in 1959 to try and entice shoppers and their automobiles back downtown and away from the increasingly popular and car friendly suburban shopping centres. Underneath the parking structure the street has been recast as Antique Alley.

Walking up Front Street you can see the painted sign for the Columbia Theatre on its fly tower and underneath that is a row of shops that utilize the huge empty space under the building which is cantilevered out over the drop from Columbia. The remaining empty space under the theatre provided a convienient garbage pit and many of the "finds" from here are on display in the lobby.

When Eaton's abandoned Columbia Street for the greener pastures of the shopping mall in the 1970s Army & Navy moved up the street to take over their building which sits on the site of one of the many locations the City Market has had over the years. Just past the store and around the other side of the building next door you can see how, with a series of steel and timber beams, one building maintains a presence on the street above.

 Walk back to Army & Navy and take the stairs up to the parking structure and then the gangway to Columbia.

Before heading out to Columbia Street take a moment on one of the parking levels to gaze out over the panorama of the river front, the hills of Surrey and the bridges crossing the river. The first crossing was the railway bridge in 1904 followed by the Pattullo Bridge in 1937 and finally the SkyTrain's cable-stayed bridge constructed in the 1980s. In the opposite direction the cable towers of the Alex Fraser Bridge are visible above the trees.

Back on Columbia walk up to 4th Street and cross to the other side of Columbia and turn left. Walk to Church Street.

On the way to the crosswalk at 4th take a look at the storefronts with their Carrera glass, marble and stainless steel accents. Carrera or Vitrolite glass was a popular material for shopfronts with its clean and bright surfaces. While other colours were available black seemed to be the colour of choice, perhaps it just looks good against the steel.

On this side of Columbia at 4th are the two buildings in the downtown to have survived the 1898 fire. On the corner the Guichon Block was originally built as the Queen's Hotel in 1887, while the Burr Block (today the Met) was built in 1892. Both buildings were designed by G. W. Grant. Look up at the Burr Block to see some interesting terra cotta tile work below the second storey windows and in the column capitals at the top of the building.

The former importance of the "Miracle Mile" can be seen in many of the surviving commercial structures on Columbia. From here there is a good view back across the street to the Burr Theatre and Canadian Bank of Commerce (CIBC). When the bank was completed in 1911 the new man-

ager was able to live "over the shop" in an apartment on the roof of the building designed by Darling and Pearson, one of Canada's preeminent architectural firms (see pg 16). They did extensive work for the bank across the country and here they have stayed with the neo-classical style which features in many of their bank commissions.

The Burr (Columbia) Theatre at 530 Columbia named for the New West native, is a real treasure for the city. Upon its opening in 1927 the theatre was celebrated for its "Moorish Renaissance" style, the "Spanish effect' of the light fixtures, and the "Moorish colour scheme" of an interior "that leads one to believe that he or she is seated in a garden". This was an "atmosheric" theatre where the goal of the design was to transport theatre patrons into a world of fantasy. The architects, Townley and Matheson, used the architecture of Spain as the inspiration for the exterior and turned to the expertise of Girvan Studios to create the effects of the night time sky and garden walls of the interior. The theatre was "twinned" in the 1970s and then sold to the Fraternal Order of the Eagles before the City of New Westminster stepped in to purchase the building. There is an ongoing restoration of the interior and the Raymond Burr Performing Arts Society produces six successful stage productions a year at the theatre.

At Church and Columbia Street Francis Rattenbury designed a Bank of Montreal branch at 511 Columbia featuring three copper domes and deep arched entrance that was reminiscent of the parliament buildings in Victoria. In 1911 the bank was robbed of almost 260,000 dollars making it Canada's largest bank robbery at the time. Unfortunately the bank was demolished in 1946 and replaced with the low squat block seen today.

Walk up Church Street to Holy Trinity Cathedral and the return to Clarkson Street, turn right and walk to 6th

The SkyTrain gets buried here on its way to Columbia Street station, which is a good thing since it doesn't obstruct the view to the Cathedral. Over its long history Holy Trinity has had a bit of a hard time with fire since the church first met as a congregation in 1859.

The first Holy Trinity was built in 1860 and five years later it was destroyed by fire. A second stone church replaced the original structure in 1867 and in 1892 it was ordained as the Cathedral of the New Westminster Diocese on the suggestion of the first bishop of New Westminster -

with the growth of the province the Diocese of British Columbia was split three ways; Vancouver Island, Caledonia and New Westminster in 1880. However, a few years later the newly minted Cathedral was destroyed in the 1898 downtown fire.

Along with his other fire related projects G.W. Grant was given the task of rebuilding the Cathedral within the remaining walls, by 1902 work was finished and the Cathedral, free of debt, was reconsecrated. However, in the 1920s it was announced that the newly expanded Christ Church in Vancouver would become the new Cathedral of the Diocese but to soothe the feelings of the congregation Holy Trinity was allowed to retain the title of Cathedral in perpetuity.

Walking down Clarkson toward 6th Street gives you a good view of the rear of the former federal building and the residential conversion it has gone through. The Cliff Block of 1910 sits solidly at the corner of Clarkson and 6th and is the work of Victoria-based architect Henry Griffith

Walk up 6th to Carnarvon, turn left and walk to the court house square.

G.W. Grant was a busy guy in New Westminster and one of his more prominent commissions was for the Provincial Court house in 1891. The original building had a dramatic roof line which was somewhat simplified when Grant was called back to rebuild the Courts inside the still standing brick walls after the fire. Flanking the old court house are the 1906 Fisheries building at McKenzie Street and the Land Registry at Lorne.

In 1981 the new Provincial courts opened across the road on the site of the old Carnegie Public Library. The library was built in 1903 using funds from Andrew Carnegie, the American industrialist turned philanthropist, who funded 2,509 libraries around the world. Carnegie did not fund the library outright but required cities receiving a gift to subsidize the library to an amount equal to ten percent of the cost of the building. New Westminster's elegant library, designed by local architect Edwin Sait, the backdrop to countless family photgraphs, served the community until 1958. It was torn down in 1960.

The Court House square has a statue of Judge Matthew Begbie the "hanging judge" by artist Elrek Imredy which was unveiled in 1981. Imredy is the sculptor responsible for Stanley Park's famous "Girl in a Wet Suit"

perched on a rock on the shoreline near Lumberman's Arch. In the plaza old granite paving stones have been recycled and used as paving accents and in the water feature.

☞ Walk through the square, cross Angnes and walk up 7th Street to Royal Avenue.

Agnes Street, named for a daughter of Governor James Douglas was shortened by the construction of the Douglas College campus in the 1980s. In 1914 Thomas Freeman, the owner of a wholesale liquor business on Front Street, and Stanley Gilchrist, the City treasurer, were among those who lived on the 700 block of Agnes.

At the corner of Royal Avenue and 7th is the lovely St Paul's Reformed Episcopal Church of 1899. Designed by C.H. Clow, it is a replica of the one destroyed in the fire of 1898. Even though the building is covered in stucco there is lots of detail still visilble. Apparently the church pews were carved by inmates of the BC Penitentiary. Note the buttresses along the sides of the building.

☞ Walk along Royal to 8th Street, turn left and walk down the hill to Carnarvon Street.

The view from the top of 8th Street to the downtown is spectacular. From this corner take a detour up 8th Street for a block to see the marvelous restoration of the Galbraith House at 131 8th Avenue. Built in 1894 for Hugh Galbraith who owned a millwork business the house, with its square corner turret and elaborate finial, was a good advertisement for the business. The family lost the house because of unpaid taxes in the 1940s and it was used as a canteen for servicemen during the war. For many years it sat on the corner of 8th and Queens slowly rotting away until its recent rescue. It is well worth a look.

At Carnarvon the pale blue building is constructed out of cast concrete blocks meant to imitate stone. Many lower mainland firms marketed the blocks as an economical building solution. The Victor Cement Block and Machine Company of Vancouver promoted the health benefits of their blocks because they allowed fresh air to circulate in the walls of the house. Here similar blocks are employed in the construction of the Odd Fellows Hall. Their three link symbol can be seen in the window lintels.

☞ Turn left and walk to Begbie Street, turn right and walk to Columbia.

The College Place Hotel, 740 Carnarvon, the former Russell Hotel, takes up the block between Begbie and Alexander with its finely detailed facade. It was designed in 1908 by the Vancouver firm of Dalton and Everleigh for Elijah Fader a city alderman and a principal of the Pitt Lake Brick and Cement Company. He is remembered by Fader Street in Sapperton. The hotel sits on the site of the eclectic home of canneryman Alexander Ewen which started out simply enough as a two storey frame dwelling in 1885 but quickly evolved through additions, upon additions into a grand multi-turreted home. Unfortunately all was lost in the fire.

Around the corner is Arundel Mansions an apartment block of 1912 designed by the firm of Thorton and Jones. It features a fabulous Arts & Crafts lobby with varnished woods, tile work and a copper plate rail. The exterior is also in a remarkable state of preservation. A testament to the care that went into its design and construction can be seen in the metal work for the pediment over the entrance; it is not the usual pressed tin or galvanized metal, but copper. When the Arundel was built it was the "last word in comfort, convienience and home-like appearance" .

A walk to the bottom of the hill brings you to Columbia Street. The SkyTrain station is just over one street to the right. But there is a lot more to explore in the city so why not find a coffeee shop, recharge and set out for the grand homes of Queens Park or the more modest Brow of the Hill.

A Short Illustrated Glossary

Sketches by Jo Scott B

Victorian Cottage

Craftsman Bungalow

Edwardian Builder, or Vancouver Box with Craftsman details

Craftsman Details

porch

porch columns

bracket and trim details

Elaborate Craftsman Home

English Revival Homes

More English Revival Homes

Mission Revival or Spanish Style

Mission Revival details

Mission Revival door styles

House with a clipped or jerkinhead gable

Some Vancouver Specials

Contractor Modern

Split Level Rancher

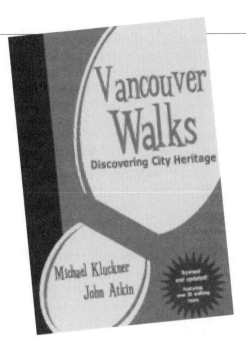

Tired of—or too tired for—the Grouse Grind? Bored with freighters in the harbour and squirrels in the park? Why not rejuvenate your mind and body with a walk through historic Vancouver?

Vancouver is a city best appreciated on foot. Whether it's the old commercial blocks of the inner city, the century-old cottages of Strathcona or the mansions of Shaughnessy and West Vancouver's Caulfeild, John Atkin and Michael Kluckner present the city's history and architecture in a fascinating set of self-guiding walking tours.

$17.95
ISBN 1-894143-07-8

Find a copy in your local bookstore or contact www.stellerpress.com for ordering information.